T0270292

BASKERVILLE

Also by Simon Garfield:

Baskerville

✳❖✳❖✳

The Biography of a Typeface
Simon Garfield

W. W. NORTON & COMPANY

Independent Publishers Since 1923

CONTENTS

❖❖*❖*❖*❖*❖*❖*❖*❖*❖*❖*

PREFACE: THE ABC OF FONTS

The moving walkway from Venice Marco Polo airport to your water taxi will take nine minutes with a heavy case if you hurry.

The sign announcing this is in a signage type: it's probably Univers or Transport or Frutiger, or one of those. It appears several times on your journey – eight minutes, six minutes, two minutes. On your metallic way you can either look at the car park and other concrete things beyond the window, or the illuminated adverts for Cartier, Brioni and Bulgari – jewellery, watches, pens, no cars obviously – all of which have a luxurious type we might associate with glamour and eye-watering prices. This typeface will often be something French like Optima, Berton Sans or Maquna, or one of those. Thin and thick highly tapered strokes, a bit of furl and curl, perhaps an elegant calligraphic hand. You're being softened up.

At the waterside concourse you have a choice. The open-top private water taxi to the Grand Canal will cost €130 and will remind you of a film with Julie Christie; the water bus costs only a tenth of this, and although it will make you feel cramped and a bit stuffy, it's how the locals do it. The water bus is called the Alilaguna, the name scrawled on its side in a badly modified version of Comic Sans or Chalkboard SE, or one of those. It is amateur and amiable, trying hard to say 'friendly!' even on the murkiest February afternoon.

It's a forty-minute trip. I suggest getting on the blue line (rather than red) and asking for Fondamente Nove, the second stop. You're on solid land now. From here it's a couple of bridges and a couple of cafés before you turn right into Calle del Fumo, a long narrow alley, and about thirty metres in you'll arrive at a printer named Gianni Basso.

This, in essence, is where commercial print-ing begins. In the early 1470s, Nicolas Jenson and Johannes de Colonia brought everything they had learnt about moveable metal type from Gutenberg in Germany, and everything they had liked in the new letter forms used by the printers Pannartz and Sweynheym at Subiaco on the outskirts of Rome, and set themselves up to print half of Venice's books. They were joined by Aldus Manutius and his

letter cutter Francesco Griffo, who would popularise italics and the concept of the portable pocket book, and they would be in competition with Franciscus Renner, Bernardinus Stagninus, Johannes and Vindelinus da Spira, Florentius de Argentina, Gabriele and Filippo di Pietro, among many others. Together, before 1500, they would print more books in this tiny cosmopolitan city than anywhere else in Europe, slightly more than Paris and Rome, vastly more than London.*

At the age of sixty-nine, Gianni Basso is the most famous printer in town, although these days it's mostly business cards and other stationery. He has thick grey hair with a proper parting, a generous paunch and an enthusiastic manner. He is everyone's pal, and his vanity compels him to remove his glasses for a photograph. His printing office has several letterpress machines, greased and inked and clanking away, a couple of them automatic and the others hand-fed, the majority from early in the last century with worn nameplates from Milan and Turin. He's been here for forty years, a celebrity client for each of them: the Sultan of Brunei, Lord Euston, Nigella

* See the Incunabula Short Title Catalogue at the British Library, a listing of more than 30,000 editions. The Venetian printers account for more than a tenth of the total (some 3,835 titles). Printing in London, William Caxton accounts for a mere 125.

Lawson, people from Apple wanting something old and original, staff from Buckingham Palace with orders to accompany their Canaletto show. He has no email address, and no sign of a computer, but a visit or the post will secure an order for letterheads in the type of your choice – Garamond, Bodoni, Italia and Augustea are always popular – on that lovely smooth wove paper which may transport you to a wood-panelled English drawing room, the steep prices reflecting the fine quality. He used to offer Baskerville in many sizes too, but the letters, stored in cases close to the floor, were ruined after the last

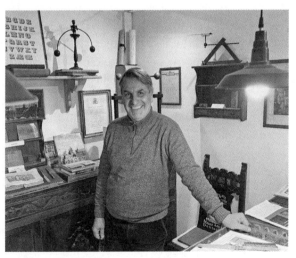

Upholding the grand tradition: the Gutenberg of Venice in his printshop.

big *aqua alta* flood of 2019, and he's yet to find a set to replace them.

Outside Gianni's shop, there are many modern types to be found all over Venice. The elaborate hand-painted signs above the old *gelaterie* are particularly attractive, as lush and swirly as their product, today reflected in modern fonts such as Budge, Gelato Script and Salsero. At the Biennale there's always plenty of Helvetica Neue, Futura, Favourit and Verlag. In the Rialto, the Fondaco dei Tedeschi, once the central post office, is now a glamorous department store; the Amo restaurant in the atrium offers lots of things with truffles, with branding all in Albertus.

But there are few modern types to be found in Gianni Basso's print shop. Orders reach him from all over the world addressed to 'Gutenberg of Venice', which he, of course, encourages. Basso likes anything that associates him with the mucky glories of old metal letters and inked wood poster types, and his walls are covered in newspaper cuttings marvelling at these exploits. Opposite his office is a shop selling funeral ornaments, pots for a loved one's ashes and the like. One of Gianni's two sons may be interested in taking over the business when his father dies, although he is also interested in skiing. Gianni is encouraged and always surprised that young

people are intrigued by 'the museum' that he runs next to his print shop. Here is the type made from lead, tin and antimony, and here is wooden type and the cases and all the necessary tools for traditional printing, and here are the old typeface sample books from long-disbanded printing foundries in Italy and France. There are a lot of books explaining both theory and technique, among them the thoughts of Bruce Rogers ('One can take almost any kind of type & produce extremely varied results by different methods of handling it.') and Stanley Morison ('Even dullness and monotony in the typesetting are far less vicious to a reader than typographical eccentricity.').

When I visited in February 2023, I fell once more for the romance of this world. It took me back fifteen years to the time I spent researching my overview of printing and fonts, *Just My Type*, but more than that it pulled me back to the time of my parents and grandparents, where so much of what they read was made this way, and almost all their personal transactions were conducted on the sort of notepaper hand-printed in workshops like these. No wonder people from Apple and Google have come to Basso's shop and drooled a little, for here they see what they couldn't quite kill. The digital takeover, slow and benign at first, and then overwhelming

and fatal, has not entirely obliterated the human desire to see words reproduced in the old way. And we forget this early craft – this distant echo of Nicolas Jenson and his friends – at our great loss.

In 2004, following the results of a survey that noted a decline in 'reading for pleasure', Andrew Solomon lamented the potential impact of this trend. 'The metaphoric quality of writing,' he wrote in the *New York Times*, '– the fact that so much can be expressed through the rearrangement of 26 shapes on a piece of paper – is as exciting as the idea of a complete genetic code made up of four bases: man's work on a par with nature's. Discerning the patterns of those arrangements is the essence of civilization.'

Solomon's observation resonates. For this is what this book is about, the formation of letters as the cornerstone of progress, diversity and ambition. The book forms part of a series, (the others examine Albertus and Comic Sans), each designed to show how one typeface came into being and then trans-formed the landscape. It will examine how a font does not magically appear, but is a result of inten-tion and historical progression, and often an attempt to solve a problem (usually the problem is 'How do I make these words clear, convincing and appeal-ing?'). It will show that the application of a font var-ies over time and will fade in and out of fashion, and

it will ask why a few typefaces endure while most leave barely a trace.*

Technological advance has not spoilt the letterform, even as it pixelates it. In fact, the opposite is true: the proliferation of computers and word processing has made us all lords of type, the dropdown menu a modern plaything. Even the Kindle offers a choice of the established fonts Baskerville, Futura, Palatino and Helvetica, alongside the new proprietary styles Bookerly and Amazon Ember. This little book will examine where just one of these options comes from.

After I'd made an order for some writing paper, Basso handed me a gift – a print, carefully laid on thick copper-coloured paper, of a poem he has hanging in both shop and museum: Beatrice Warde's 1932 broadside 'This Is a Printing Office'. This is a sign (a proclamation, a hope, a protest, never actually intended as a poem but as lyrical as Milton) that was once displayed in every hot-metal workroom with a sense of its own worth. This is also what this book is about – an attempt to weigh the value of words, printing and its effects. Basso's version was in

* I am using the words typeface and font interchangeably here, as is the colloquial way. Strictly, a typeface is the big, overall name for a design (Baskerville), while font denotes a particular style or weight within a typeface family (Baskerville Bold, or Baskerville Italic).

Garamond, printed from metal letters, but here it is in a digitised revival of Baskerville:

THIS IS A

PRINTING OFFICE

*

CROSSROADS OF CIVILISATION

REFUGE OF ALL THE ARTS

AGAINST THE RAVAGES OF TIME

ARMOURY OF FEARLESS TRUTH

AGAINST WHISPERING RUMOUR

INCESSANT TRUMPET OF TRADE

*

FROM THIS PLACE WORDS MAY FLY ABROAD

NOT TO PERISH ON WAVES OF SOUND
NOT TO VARY WITH THE WRITER'S HAND
BUT FIXED IN TIME
HAVING BEEN VERIFIED BY PROOF

*

FRIEND, YOU STAND ON SACRED GROUND
THIS IS A PRINTING OFFICE

This book is about how the Baskerville typeface came to be, and how and why it has endured. It is a story of a quest – for perfection, for recognition – and it chronicles the unconventional life and restless death of the brilliant man who gave the type its name. The tale begins at an incendiary period in English history when the possibility of political and cultural revolution accorded both threat and thrill.

1. THE RIOTS

On Thursday 14 July 1791, about ninety men gathered for a late lunch at the Royal Hotel in Birmingham, and as soon as it was over the town went up in flames.

The diners had spoken of inflammatory things – freedom of speech, religious tolerance, support for the French Revolution – and no one present could have been surprised at the fearful reaction that greeted them. The timing of their celebratory meal, on the second anniversary of the storming of the Bastille, was provocative enough, and it was greeted in the days before by unguarded threats.

The mob that greeted the enlightened and privileged diners were after one man in particular, the brilliant chemist, political theorist and radical preacher Joseph Priestley. Today we remember Priestley for his discovery of carbon monoxide, ammonia, hydrogen chloride and other gases, and

for his co-discovery with Carl Wilhelm Scheele of oxygen, but his enemies marked him out as a dangerous individualist who thought little of challenging age-old institutions. He had been advised not to attend the lunch, but his absence was no defence when the rioters attacked his house at Fair Hill. He escaped with his life and family, but his laboratory and most of his possessions were torched.

The following day the mob went looking for other targets, including Moseley Hall, the family home of John Taylor, the son of the co-founder of Lloyds Bank, and then on to the home of William Hutton, an alderman and bookseller, and Birmingham's first historian. Twenty-seven private residencies were destroyed before constables stepped in and read the Riot Act (they were in no hurry; they too saw the dissenters as disruptive to their well-being). Another target was John Ryland, who had made his money from wire and pins and lived at Easy Hill, a seven-acre estate overlooking the city, a fabled mansion of mahogany and marble, china closets, good cellars, seven bedrooms, servants quarters, a brew house, pumps for both soft and hard water, a four-stalled stable, a coach house, a greenhouse, a workshop, fish ponds and a grotto. William Hutton described it as paradise.

This too was set ablaze, leaving a brick shell and, because they were too drunk to get out from the cellar in time, the charred bodies of several rioters. Among the ruins on the estate stood a strange-looking conical building that was once topped by a windmill. By the side of the mill, which was perhaps once used for paper production, or perhaps iron flattening, lay a mausoleum with the inscription:

Stranger –
Beneath this Cone in Unconsecrated Ground,
A Friend to the Liberties of mankind Directed his Body to
be Inurned
> *May the Example Contribute to Emancipate thy Mind*
> *From the Idle Fears of Superstition*
> *And the Wicked arts of Priesthood.*

The mob couldn't touch him, can't touch him still, for here in the earth lay John Baskerville.

Only many years later would they dig him up, and then dig him up again, and bury him for the third time, but that's a darker story.

2. JAPANNING

John Baskerville was baptised in the Worcester-shire village of Wolverley on 28 January 1707, and little was heard of him until his life began to flower nineteen years later. His parents had the sur-name Baskervill, they owned a little land and did a little farming, and his father ran an inn that probably doubled as a brothel. They managed to provide their son with a good education, and while at school he displayed a talent for handwriting. His nonconform-ist streak may also have shown itself early; certainly, he was keen to make his way and make money, a champion of the notion that in Birmingham many men approached on foot and left in chariots.

When Baskerville arrived in 1726 the town was still small; it wouldn't elect a representative to Parliament for more than a century. Its population stood at about 10,000; in 1731 there were 3,756 houses on fifty-one named streets concentrated within a quarter of a mile. Travellers would find no hotels, while the weekly coach journey to London would take the best part of three days.

Despite its size and insularity, the town took pride in its local industry. It became known as a

place where value was added: its skilled craftsmen
– masons, jewellers, metal workers – expanded their
specialisms throughout the eighteenth century to
make Birmingham the centre of the 'toy' industry,
although these were solely toys for adults: smallish
ornamental and luxury items including buttons,
buckles, snuff boxes, tankards, coffee pots and can-
dle sticks, all easily saleable and transportable be-
yond the town.

John Baskerville would have seen the expansion
of these trades, and the riches to be made from them,
as he laboured as a handwriting instructor at a small
school in Birmingham, where he again tried to make
the written language both legible and handsome.
At the time, handwriting 'had its natural beauty',
said Francis Meynell in a lecture on Baskerville to
the Society of Royal Designers for Industry in 1952.
'The current cursive hand was not yet perverted
by steel nibs and even worse by such new devices
as ball-pointed pens.' Of course it wasn't: it was all
still inkwells and quills plucked from birds, and the
letters they created carried a distinct form and a
studied flourish, a perfection achieved over months
and years. Baskerville extended his teaching beyond
schoolchildren to the training of young men for
clerical work, and to what the typography scholar
Beatrice Warde called 'teaching young ladies those

sinuous flourishes that are so effective in an auto-graph album'.

But there was little money in it, and Baskerville's ambitions extended far beyond the classroom. By 1730 he was also practising stonemasonry, special-ising in gravestones, many of them no doubt still haunting Birmingham's burial grounds, but none of them, alas, now identifiable as his. But this work didn't pay enough either, and nor did his early for-ays into type and printing, but at the age of thirty Baskerville found something that might. These days we may call the items 'fancy goods', domestic lux-uries for those with money to spend and a taste for the East.

By the end of the seventeenth century, about 3,500 cabinets, chairs and smaller items coated with dark oriental lacquer were being brought to England each year by the English East India Company, the majority from China, some from Japan, a few from India. As the resin required for this lacquerware was made from the sap of *Rhus vernicifera*, a tree not cul-tivated in Europe, and the process required up to a hundred coats of this substance, anyone able to create a substitute varnish resembling the lacquer would find a large demand.

The technique known as 'japanning' found a stronghold at the Pontypool Iron Works in South

Wales in the 1730s. The method seems to have evolved from tin-plating iron to prevent rust, this new black or crimson coating providing another layer of protection and a more attractive one, and its surface would readily take decoration. It was a complex process involving many levels of slow baking and careful coating over several days, and it wasn't until its manufacture spread to the skilled workers of Birmingham that the practice was streamlined and its full commercial potential realised. The first to exploit it was the enamel maker John Taylor (twenty years before the mob destroyed his home), but John Baskerville wasn't far behind. There is a fantastical story in a journal of 1807 in which Baskerville is depicted as spying on Taylor, tracking him as he visits every supplier of japanning ingredients in the course of a day and ordering the same quantities in the hope of replicating the formula.

More probably, Baskerville learnt of the technique by copying the manufacture of the japanned handles made by the cutler who occupied the work premises next to his own. There were many manuals too, each with their own recipes, none more influential than *A Treatise of Japanning and Varnishing* by John Stalker and George Parker (1688), which served as both artistic guide and sales catalogue. 'We have laid before you a Art very much admired by

us,' the authors explained, 'and all those who hold any commerce with the Inhabitants of JAPAN; but that Island not being able to furnish these parts with work of this kind, the English and Frenchmen have endeavoured to imitate them; that by these means the Nobility and Gentry might be completely furnisht with whole setts of Japan-work.' Their recipe included lamp black, wood tar and copal resin. Their claims stated their lacquer was fireproof, waterproof, mould-resistant and the enemy of both 'corroding time' and 'mouldring worm'. Once demand was sufficiently high among the newly emergent industrial classes, Baskerville sought a patent of his own.

Baskerville made his fortune from these lacquered goods, specialising in treating the iron of candlesticks, tea trays, picture frames, toiletry boxes and small tables. The patent granted to him in 1742 allowed him 'to Japan or Varnish ... [to] produce a fine glowing Mahogany Colour, a Black no way inferior to that of the most perfect India Goods, or an Imitation of Tortoiseshell which greatly excels Nature itself both in Colour and Hardness'. The surfaces were decorated with elaborate and still (to us, from prints) wholly familiar Japanese images – pagodas, rushing rivers, water carriers, cherry blossom. Baskerville also engaged local artists to use vermillion, copper and mercury to decorate

his wares with birds, flowers and landscapes copied from famous paintings. When customers ventured to Birmingham to call on his workshop they were overwhelmed by the range and beauty on offer.

Baskerville's innovations extended to milling a fine type of iron with an even flatness, lengths of which could be almost imperceptibly joined together. 'Baskerville is a great cherisher of genius which, wherever he finds it, he loses no opportunity of cultivating,' wrote the Irish writer Samuel Derrick to the Earl of Cork in 1742. 'One of his workmen has manifested fine talents for fruit-painting, in several pieces which he shewed me.' In the 1750s, working as postmaster general of British America, Benjamin Franklin also toured Baskerville's premises and bought several japanned trays. In 1771, the steel toy and plate maker Matthew Boulton and his sales agent John Fothergill wrote to a prospective client in London that her desire for bread baskets, inkstands, kettles and coffee pots would be fulfilled by Baskerville with ease, for he was 'one of the most imminent Jappaners in Birmingham and we doubt not is capable of serving you'.

Baskerville was his own best marketeer, not least when he paraded around town in an ornate coach, or what one observer called 'a most gorgeous chariot', drawn by four cream-coloured horses, its

panels 'done up in the japanware fashion'. The luxury he purveyed to others amplified his own flamboyance: his dress became more elaborate – more velvet, more frills – and his demeanour more grand. Francis Meynell told his audience that Baskerville gained the reputation of a 'card', and 'a fop and a coxcomb'. Our image of him derives principally from three contemporary writers. In his anecdotal collection from 1812, John Nichols recalled a man who was 'remarkably polite to the stranger, fond of shew: a figure rather of the smaller size, and delighted to adorn that figure with gold lace. Although constructed with the light timbers of a frigate, his movement was as stately as a ship of the line.' William Hutton, Birmingham's first biographer, wrote in 1781, 'His favourite dress was green, edged with narrow gold lace; a scarlet waistcoat, with a very broad gold lace; and a small round hat, likewise

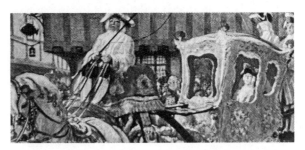

A most gorgeous chariot: Baskerville on a cigarette card in the 1930s.

edged with gold lace.' The early nineteenth-century bibliographer T.F. Dibdin concluded that Baskerville was 'a wonderful creature as an artist, but a vain and silly man'.*

The only known contemporary oil painting of Baskerville, the portrait by James Millar from 1774, made when its sitter was sixty-seven and in the last full year of his life, shows a man seemingly content with life, plump of face with a knowing and kindly demeanour. The original is in the Birmingham City Museum and Art Gallery; a copy, probably commissioned by the legal reformer Joseph Parkes (1796–1865), was acquired by the National Portrait Gallery in 1905, where it was described in a catalogue of 1977 as showing a man with 'pale blue eyes, protruding lower lip, double chin, fresh complexion'. He wore a short grey wig with two rows of curls, a thin white scarf and lacy wrist ruffles protruding from the

* A series of John Player cigarette cards issued in the 1930s featured fifty men classed as 'Dandies'. These included Sir Walter Raleigh, Beau Brummell and Murat, King of Naples. There are many Regency bucks in swashbuckling garb, none of whom would last a minute onstage at the Glasgow Empire. And of course there's John Baskerville, no. 17, portrayed not posing like all the others but in his fancy carriage being pulled by cream-coloured horses. The accompanying text is plain: 'In his gold-laced coat and scarlet waistcoat, Baskerville must have been an imposing figure … But he was not the man to live in idle luxury: he set up a type-foundry in which he cast types which made him famous throughout Europe, and he also produced (generally at his own risk) some of the finest printing in the world.'

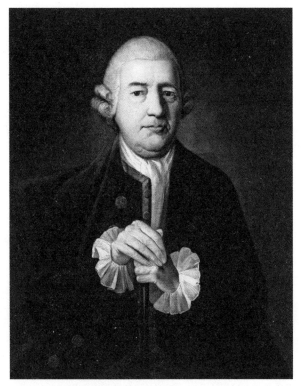

The great cherisher of genius: John Baskerville in 1774.

sleeves of a dark-brown collarless velvet coat set off by golden buttons and edged with a golden braid. He sits upright on a dark red velvet chair, his hands, right over left, rest gently on a black stick. Writing in 1812, John Nichols found, 'During the twenty-five

last years of his life, though then in his decline, he retained the singular traces of a handsome man. If he exhibited a peevish temper, we may consider that good-nature and intense thinking are not always found together.' In Millar's oil portrait he looks at peace with the world. His fingernails are not at all inky.

3. MISPRINTS

An edition of John Baskerville's first book goes up for sale at Bauman Rare Books on Madison Avenue, New York City. Bauman was established in 1973, and has always been more a shrine than a shop, a place where even the most self-contained visitor ends up drooling. An online trawl might also have you helpless. Here is the second royal octavo edition (1856–7) of Audubon's *Birds of America* in brown Morocco, and the first edition, first issue, of Joseph Conrad's *Youth* (1902), original green cloth and green cloth clamshell box, a volume that also includes the first appearance in book form of the novella *Heart of Darkness.* You will find a four-page handwritten letter from Charles Darwin agreeing

to a second American edition of *Origin of Species* at a slightly higher price and committing his publisher to the first American printing of *The Descent of Man*. And then there is the first edition of Anne Frank's diary from 1947, original Dutch and original jacket, one of only 1,500 copies. The asking prices are $58,500; $95,000; $125,000; $28,500.

And then there is the Baskerville volume from 1757, the first book he published at his own press and with his own typeface, in period-style marbled calf gilt, with burgundy morocco spine labels, marbled endpapers, Quarto (303 × 228mm; approximately 12 × 9 inches), all edges gilt, a collection of Virgil's poetry in the original Latin entitled *Bucolica, Georgica, et Aeneis*, highly beautiful and highly sought-after.

Baskerville was fifty-one when he printed it, his first masterpiece, a product of deep passion and long dedication, made possible only by the fortune he had amassed from japanning. The Bauman catalogue quotes Lord Macaulay's *The History of England*, which describes Baskerville's early editions going forth 'to astonish all the librarians of Europe', and also T.F. Dibdin's assertion that Baskerville's *Virgil* is 'one of the most finished specimens of typography'. And this was the rare first edition, overlaid with several hand-pasted strips or 'cancels' correcting printing errors, and four names 'too late to

be inserted alphabetically' added to the list of the book's subscribers.

The book announced Baskerville as a fine printer and a pioneering one. The second half was printed on traditional laid paper, but much of the first was printed on wove paper, probably the first time this had been done in Europe. Wove paper, acquired by Baskerville from James Whatman's mill in Maidstone, Kent (the principal supplier, too, of sketching paper for J.M.W. Turner), provided a much

PUBLII VIRGILII

MARONIS

BUCOLICA,

GEORGICA,

E T

AE NE I S.

BIRMINGHAMIAE:
Typis JOHANNIS BASKERVILLE.
MDCCLVII.

Baskerville makes his first book beautiful: Virgil's poetry from 1757.

smoother surface, which Baskerville 'glazed' further before binding by pressing between hot plates; it was like ironing wrinkles out of sheets, the wrinkles in this case being the indentations made on paper by the traditional letterpress technique. Baskerville's method ensured a more even impression on paper and thus a greater clarity for the reader; there was less smudge, less unwanted residual ink beneath the printed letter. The density yet accuracy of the ink, the glossiness of the paper and the spacious lay-out combined to provide the reader with what one American bookseller called 'a particularly gratifying feeling of strength and serenity'.*

* This was Phillip J. Pirages Rare Books of McMinnville, Oregon. The difference between laid and wove paper has been described as the difference between linen and silk. The smoothness of wove paper, already widely used in East Asia, was achieved by using a mould covered with a fabric of uniformly woven fine brass wires in place of the traditional single parallel 'laid' brass wires that were stitched together at intervals. When Benjamin Franklin visited Baskerville's printing works at Easy Hill he was impressed with the great pains taken to improve every method of production. Returning to Philadelphia in 1762, he employed wove paper in his own printing press. James Whatman's innovations with these papers were not without their initial flaws, and the first edition of Baskerville's *Virgil* displays the clear marks of the wires used in its production. For the second edition, and indeed for all but two of his subsequent books, Baskerville relied on laid paper, usually of a more refined sort than had been previously used by most publishers, choosing between several finishes, what the bibliographer Philip Gaskell classifies as light, heavy, ordinary and fine. Supply may have been as influential a factor as design: John Milton was treated to both methods – laid for *Paradise Lost* in 1758, wove for *Paradise Regained* a year later.

Benjamin Franklin bought six copies, while every conscientious librarian and bibliophile sought to acquire one for their collection. The print run was nine hundred copies. Baskerville sold approximately seven hundred to subscribers at one guinea (£1 and 1 shilling); the final two hundred he was obliged to sell for 14 shillings. Eleven copies found their way to Yale, where scholars have delighted in comparisons of the printings, not least the anomalies and cancellations (corrections). In 1937, for example, Professor Allen Hazen studied ten of the copies for the *Yale University Library Gazette*, confirming a 'nervous fastidiousness' in the printer: 'If ever there was a book that was made fascinating by its misprints, this is it!'*

* Some of these are the simple misnumbering of pages (319 for 316 etc.) or amendments to punctuation. Other changes concerned catchwords, the first word of the next page added to the foot of the present one to enable the printer and binder to match pages, and the eyes of a reader (and especially an orator) to transfer smoothly from one page to the next. Today these errors may remind us how the printing, cutting, compilation and binding of pages from a much larger original sheet was not a straightforward process (the Quarto size of Baskerville's *Virgil*, roughly twelve inches by nine, began as one sheet printed with eight pages, four to each side.)

Four years later, in 1761, John Baskerville printed *The Works of Mr William Congreve* in three volumes, and to handle just one of these 260 years later is to be transported to a time of expansion and enlightenment. The machinist Matthew Boulton had just bought thirteen acres of land two miles from the centre of Birmingham he named Soho Works, a powerhouse of tool and steam-engine manufacture that would, with the guidance of John Fothergill and James Watt, drive tin mines in Cornwall, breweries in London and water around the palace of Versailles. Boulton and Watt were both members of the Lunar Circle, the learned society that met on the full moon to discuss manufacture, philosophy and the natural sciences; other luminaries included potter Josiah Wedgwood, physicians Erasmus Darwin and William Small, author Thomas Day and chemist James Keir. Benjamin Franklin would attend their meetings sporadically, alongside the geologist James Hutton and Rudolf Erich Raspe, the author of *The Surprising Adventures of Baron Munchausen.*

Baskerville would attend occasionally. For these men were his subscribers and readers, and their taste influenced the printer's choice of publication. The volume of Congreve I pulled from the shelf

at the London Library is stout and pocketable at approximately 5 × 4 inches, a book to be carried around and treated in the casual way we may treat a paperback today, a commonplace pleasure, a contrast to the Virgil presentation volumes and other classics in this set – his Horace, Lucretius and Catullus. But this edition is also a non-fugitive token. It is still fairly tightly bound, and because of Baskerville's newfangled printing methods it still seems perfectly modern today. I'd argue that the spine and binding hold up better than the satire within, the plays *The Old Batchelor* and *The Double Dealer*. The frontispiece carries a finely reproduced line engraving of the playwright by Gottfried Kneller, Congreve's face ringed by a high and long pomp of curls, a fashionable wig not unlike Baskerville's own. The text sometimes appears to float on the surface, benefitting from the generous white space around and the addition of repeated lines of ornamental pattern known as 'lozenge and star'. I joined a long line of admirers: in Virginia Woolf's *Night and Day* (1919), the character William Rodney entertains a guest at home. In one hand he holds

a glass of whisky, and in the other 'the Baskerville *Congreve* … I couldn't read him in a cheap edition'.*

But this volume also contains a good smattering of pasted corrections, a trait Baskerville seemed to regard as essential in his attempt to produce the perfect book, and an acceptable trade-off for his large and ambitious output. While other printers seemed content to let readers make their own corrections, Baskerville attempted to pre-empt this chore by doing it for them, sometimes by stopping the press when a new error was found. The same year he published his three volumes of Congreve, he also produced four volumes of the works of Joseph Addison, the *Satyrae* (satirical poems) of Juvenal and Perseus, and an edition of Aesop's Fables (he produced fifty-six books between 1757 and 1774). In the case of Robert Andrews' translation of Virgil, *Virgil Englished* (1766), the author insisted on changing his version when the book was already in proof, resulting in more than forty visible overlaid amendments. In 1773 a revised

* 'Cheap' may have a dual meaning here: the first 'less refined, common'; the second a monetary one. Baskerville's books were consistently more expensive than those of other publishers, particularly those he printed and sold himself. One of his regular correspondents, the poet William Shenstone, suggested it may be more than twice the cost. Most of his books were priced and sold unbound, although the similarity of many of his surviving bound volumes suggests he may have pointed purchasers in the direction of a favoured local bindery in London or Birmingham.

printing of Baskerville's four-volume set of Ariosto's *Orlando Furioso* contained a record-breaking sixty-six cancels. And these were just the ones that were spotted: many of Baskerville's books contained errors that stayed uncorrected. In 1959 a bibliography by Philip Gaskell concluded, 'Baskerville spared neither pains nor money to make his books as fine as he could, but his standards of textual accuracy were too low for the results to be entirely successful; most of his books were unusually beautiful, expensive and incorrect.'

Why this anomaly? Overambition, the difficulty of the craft, the competitive and jealous demands of the market, a desire to recoup the huge costs – financial and emotional – that got him into this trade in the first place, a quest for the most refined and useful letters in the world, the lasting cause of his fame.

4. THE ART OF CUTTING

Baskerville first revealed his grand ambitions in 1758. 'Amongst the several mechanic Arts that have engaged my attention,' he wrote in the preface to his edition of Milton's *Paradise Lost*, 'there is

no one I have pursued with so much steadiness and pleasure, as that of *Letter-Founding*. Having been an early admirer of the beauty of Letters, I became insensibly desirous of contributing to the perfection of them.' Accordingly, he had 'endeavoured to produce a *Sett* of *Types* according to what I conceived to be their true proportion.'

Baskerville singled out one contemporary model for his own excellence. 'Mr Caslon is an Artist, to whom the Republic of Learning has great obligations; his ingenuity has left a fairer copy for my emulation, than any other master … I honour his merit, and only wish to derive some small share of Reputation, from an Art which proves accidentally to have been the object of our mutual pursuit.'

It is not clear why Baskerville regards their joint pursuit 'accidental'. We have seen how he came to his new craft from his early professional years as a writing master and stonecutter, and he had declared his printing ambitions well before japanning made them financially viable. He was fortunate to live when he did. Until 1695 a state decree had proclaimed the only locations permitted to print anything at all were London, York, Oxford and Cambridge; subversive material was more easily controlled that way; licences could swiftly be rescinded. In Birmingham, Baskerville had no thoughts for sedition: his plan

was to produce a limited amount of the finest classics, 'books of *Consequence*', which his readers 'may be pleased to see in an elegant dress, and to purchase at such a price, as will repay the extraordinary care and experience that must necessarily be bestowed upon them'.

One publication in 1750 may have inspired him further. An article in the *Universal Magazine* entitled 'The Art of Cutting, Casting and Preparing of Letter for Printing' was accompanied by an engraving purportedly showing the workings of the Caslon foundry in London. The whole mystery of making letters – the practical side of the apparatus if not the artistic flair – was laid out in simplified terms, and it may be the right time to consider it here (in even more simplified terms).*

A single letter or punctuation mark begins with a hand-drawn letter which is then cut into a punch, a thin strip of metal (perhaps three inches high and a quarter-inch square for 12-point) on which a

* The *Universal Magazine* relied heavily on passages in *Mechanick Exercises* by Joseph Moxon (1683), one of the earliest printers' manuals explaining what had hitherto been a secret art. There may have also been another influence on Baskerville to begin his type work in earnest: Caslon's biographer Johnson Ball mentions that Amos Green, a relative of Caslon, began working for Baskerville as an apprentice in his japanning business in 1748. He specialised in flower painting but was 'an ingenuous youth who might easily be persuaded to give away any information he might possess regarding the Caslon establishment.'

character – a letter, number or punctuation mark – is carved as a mirror image at its apex. Working with varying temperaments of steel, Baskerville's punch-cutters might require a day to create a single letter. This was then stamped with a mallet (punched) into a matrix of softer metal, predominantly copper, and the matrix then secured in a hand-held mould, into which hot metal (a mixture of lead, tin and antimony) is poured to create multiple copies for printing. I've made it sound easy, but the parallel processes used in each part of the process – the use of a counterpunch to create negative space, the dexterity required to ensure uniformity of style, depth and height, the jus-tification of the cast letters with files – all required vast reserves of time, patience and expertise.*

By the time he announced himself with his

* An explanation of casting written by Fred Anthoensen in 1939, echoing Joseph Moxon's explanation from 250 years earlier, provides a glimpse of just one aspect of this complexity: 'Wherefore placing the under half of the mold in his left hand, with the hook or hag forward, he clutches the ends of its wood between the lower part of the ball of his thumb and his three hind fingers; then he lays the upper half of the mold upon the under half, so as the male gages may fall into the female gages, and at the same time the foot of the matrice places itself upon the stool; and, clasping his left hand thumb strong over the upper half of the mold, he nimbly catches hold of the bow or spring with his right hand fingers at the top of it …'. It goes on for many lines yet; maybe the tying of shoelaces would require the same written instruction. The complex effort bore wonderful fruit: find any book from the eighteenth or nineteenth century and marvel at the impression of ink on paper – craft, art, pain and devotion in one.

Virgil in 1757, Baskerville had spent seven years and about £1,000 perfecting his types. The 'pleasure' he describes from this pursuit did not derive from the simplicity of this work, but its opposite: the establishment of a new alphabet in various sizes – nothing less than an attempt to improve the reading experience for those he considered 'with taste' – became an obsession that would have detrimental effects on his health, 'the most intense Application to the great prejudice of my Eyes'.

His painstaking dedication, which may be pointedly reclassified as mental anguish, is best witnessed in the correspondence between Baskerville and the printer and playwright Robert Dodsley from the autumn of 1752, still five years before his first alphabet would be ready for his first book. Dodsley had agreed to publish an edition of poems by Thomas Gray, including *Elegy Written in a Country Churchyard*. The poem had already been published, and its popularity had inspired Horace Walpole to propose a new large-scale printing with accompanying illustrations from his protégé Richard Bentley. Dodsley had suggested that Baskerville's new type and presses, though yet to be completed, would be perfect for the task. How he learnt of Baskerville's ambitions is unclear, although he would soon come to regret the connection.

Baskerville's perfectionism – combined with the inevitably slow process of trial and error – would prove frustrating for those awaiting his finished work. A short while after he had commissioned Baskerville to print the book, and after he had seen some early proofs of the text, Dodsley had enquired of its further progress. Things were going very well, the type founder replied, aware that no other response would have satisfied.

To remove in some Measure yr. Impatience, I have sent you an Impression of the punches of the two lines Great primer, which have been begun & finish'd in 9 Days only, and contain all the Letters Roman necessary in the Titles and half-Titles. I can't forbear saying they please me, As I can make nothing more Correct, nor shall you see any thing of mine much less so. You'll observe they strike the Eye much more sensibly than the smaller Characters tho Equally perfect, till the press shews them to more Advantage; The press is creeping slowly towards perfection; I flatter my self with being able to print nearly as good Colour and smooth a Stroke as the inclos'd; … The R. wants a few slight Touches & the Y. half an hour's Correction.

This Day We have resolutely set about 15 of the same Siz'd Italick Capitals, which will not be at all inferior to the Roman, & I doubt not to compleat them in a fortnight. You Need therefore be in no pain about our being ready by the time appointed. Our best Respects to Mrs Dodsley & our friend Mr Beckett ...

Before we consider just how optimistic this letter was, it will be useful to define some terms. 'Colour' for a typographer has nothing to do with chroma; rather, it describes the perceived presence of a letter or word on a page – an imprint either light or dark, a contrast faint or distinct, a texture flat or rich (or any point between these extremes). In Baskerville's case, he was boasting of a firm and effective impression on the page, and a freshness or crispness seldom seen before. He would have sent Dodsley a handmade 'smoke proof' of his letters, a unique carbon print made by holding a flame to his carved metal letter before pressing it to paper; he hoped that his presses – still being built – would achieve a similar effect.

The 'two lines Great primer' he mentions is a reference to size. Baskerville had one roman and one italic typeface to offer, but they came in a large variety of sizes. The terms are largely defunct today,

but correlate closely to our modern point system. Baskerville would eventually offer type specimens in fourteen sizes of roman and nine italics. In roman, from small to large with the modern point equivalent: Nonpareil (6 point), Brevier (8), Burgeois/Bourgeois (9), Long Primer (10), Small Pica (11), Pica (12), English (14), 2-line Brevier (16), Great Primer (18), Double Pica (24), 2-line English (28), 2-line Great Primer (36), 2-line Double Pica (40), French Canon (48), 5-line Pica (60). Excluding titles, he planned to print Gray's poems in Great Primer. The standard text of the majority of books printed by Baskerville in his lifetime would be in English size, with variations in Burgeois (for psalms), Pica and Great Primer. Consulting one of Baskerville's specimen sheets is rather like reading an optician's eye chart, although the tiny Nonpareil is negotiable only with a magnifying glass, and Bourgeois suitable only for footnotes.*

What did Robert Dodsley perceive of Baskerville's confidence? We do not have his reply,

* Never one to follow tradition, Baskerville's type sizes were slightly larger than those of his predecessors, not least Caslon. Several were one size up: his Pica, for example, was approximately the size of Caslon's English. In a letter written later (possibly 1773) to the president of the French Royal Academy of Sciences, Baskerville expressed further claims of originality: 'My letters are not (one of them) copied from any other; but are wrought from my own ideas only.'

but we suppose he expressed further urgency. For a little over two weeks later, on 19 October 1752, Baskerville tried to reassure him again. 'You may depend on my being ready by your time (Christmas) but if more time could be allow'd I should make use of it all in Correcting and justifying.' So much, he assured his friend, 'depends on Appearing perfect on first Starting ...'

In the same letter Baskerville listed his progress. He had made smoke proofs of twenty more italics, and was now working on numbers. The letters were being prepared 'with all the Care & Skill I am Master of'. But having seen no fault in his own progress, he was less complimentary about the plates of the ornamental initials engraved by Richard Bentley: 'He's greatly deficient in Design Drawing and Execution with the Needle ... To Speak in my own Way the D is as bad a one as can well be made.' Inevitably he wished Dodsley to keep these thoughts 'inter nos only'.

John Bidwell, former curator of printed books at the Morgan Library & Museum in New York, analysed these letters in the *Book Collector* in 2002, reasoning that Baskerville had hoped to print the initials himself in his large 2-line Great Primer and have them decorated by his own engravers. 'Baskerville was manifestly incapable of keeping

the promises he made in this letter. After working on his type for two or more years, he and his assistant were still cutting punches, but now he expected to finish the punches, justify the matrices, cast the type, set it up, correct it, and print the book in only nine weeks.'*

The tension between art and commerce is now clear. While we can detect the urgency from Walpole in Dodsley's ear, we are aware merely of a slow creative process in Birmingham. 'Baskerville could afford to wait for years before he received any return from his printing affairs,' Bidwell notes. His profits from japanning are not only keeping him afloat, but have secured in the printer a quest for a similar reputation and success in his new field. His explanation to Dodsley about the patience required for successful type founding was something he was only just discovering himself.

The saga continued. Further desperation from Dodsley brought on more placation from Baskerville. In his third letter he again assured him, 'I shall be ready a Good while before Christmas, I

* The *Book Collector* had been established in 1952 by Ian Fleming, the same year he wrote his first Bond story, *Casino Royale*. The first two letters from Baskerville of October 1752 are at the library at Columbia University, while the third, undated but probably written at the very end of the month, is at Princeton.

don't wonder at your patience being almost worn out.' He also confirmed that 'no time has, or shall be lost', the only losses being 'the Advantage of being tolerably perfect at first Starting'. The definition of 'tolerably Perfect' is a novel one; he hoped, in fact, that his Great Primer 'will stand as long in Line as Mr Caslon's paragon or nearly as long as his double pica'. Indeed, he considered his work to be so fine that Caslon's printing was judged to contain 'extreme bad Characters' in comparison (and this for someone he once so admired).

The concept of legacy was now paramount. The success of his japanning trade, his inclusion as a guest in the Lunar Society, his outward flamboyance and sartorial delight – all had amplified his self-regard. Books such as his would be as much about appearance as content, more about show than consistency, and he hoped they would cement his reputation among the intellectual elite in Birmingham and London. He believed that Birmingham was already on his side, and he told Dodsley of his desire to 'perswade the publick into the same good Opinion of my Skill in Letters as the people have here … If I succeed in the Reputation I hope for I shall think my Self amply paid, without putting one Shilling in my pocket.' But there was also a statement that would set Dodsley and Walpole trembling. Because reputation

and tolerable perfection meant everything, 'it would be abundantly worth your while to stay Six months could I not be ready sooner.'

Despite Baskerville's high self-regard, he was happy to praise when he saw fit. Richard Bentley's new frontispiece was so 'finely imagin'd' that it 'Cur'd the pain I received [from his earlier work] which I assure you was not a little'. The only problem he saw now was the extraordinarily large paper size, 15½ inches by 11½, producing margins that would swamp the poems (he stressed that this was a pamphlet rather than a book; it was like cutting a coat with superfluous cloth). Even then, he suggested, the dynamism of his letters would still look striking.

Baskerville designed the type on paper but didn't cut all the metal letters himself. He relied on the skill of John Handy, whom he described as his 'operator'. (Handy had probably learnt his craft as a copperplate engraver in Birmingham's glass and jewellery trades. He remained at Baskerville's workshop for twenty-eight years, but there is also evidence of two other punchcutters at work.) Baskerville assured Dodsley that Handy was committed to the printing of Gray's poems quite as much as he was, 'nor does he spare any pains & Care; he is here by five o Clock in a morning'.

But the assurances were not enough. Early in November Walpole and Dodsley decided that their publication couldn't wait, and chose instead an (un-identified) printer to work at the Strawberry Hill Press Walpole had set up at his home in Twickenham, south-west London. The delays had cost them a Christmas sale, the work eventually appearing in March 1753, still four years before Baskerville's first book was ready. A range of large Caslon type was used in place of Baskerville, and the pamphlet was well received, Richard Bentley's illustrations in particular meriting several editions. We have no account of Baskerville's reaction to this abandon-ment. He may have been disappointed after such careful work, but he may also have been relieved to be free of the pressure. John Bidwell believes he dodged a bullet. 'Such a splendid book might have boosted Baskerville's career but would have blunted the impact of his types. They needed to stand alone, framed by generous leading and ample margins, attended by ornament only on special occasions and in small amounts.' Besides, Baskerville would soon benefit from having his work judged as a new art form in itself, rather than an accompaniment to it. 'His types and typography,' reasons Bidwell, 'upheld the principles of purity, poise, harmony and restraint.'

5. TRUST EXERCISE

On 9 July 2012 the film director Errol Morris asked a simple question in an online article for the *New York Times*: 'Are You an Optimist or a Pessimist?'

Morris was best known for his films *The Thin Blue Line* and *The Fog of War*, which won the Oscar for Best Documentary in 2003. He has always been drawn to irreverent and unnerving subjects, once hoping to make movies about a giant chicken, the afterlife of Einstein's brain, and a popular insurance scam in Florida which involved the deliberate loss of limbs. The subject of his work occasionally changed course dramatically as it was being made.

His article in the *New York Times* appeared to be one thing but was in fact another. On the surface it was about the danger posed by an asteroid hitting the earth. Morris quoted a passage from a book by the British physicist David Deutsch:

> If a one kilometer asteroid had approached the
> Earth on a collision course at any time in human
> history before the early twenty-first century, it
> would have killed at least a substantial proportion

of all humans. In that respect, as in many others,
we live in an era of unprecedented safety: the
twenty-first century is the first ever moment when
we have known how to defend ourselves from such
impacts, which occur once every 250,000 years
or so.

Morris then asked his readers two yes-or-no ques-
tions. Did they think it was true that we live in an
era of unprecedented safety? They were then asked
how confident they felt in their conclusion: slightly,
moderately or very.

More than 45,000 readers responded online.
They were told to expect an analysis of their replies
in a few weeks, and also 'a surprise'. A month later
they found that the surprise was about typefaces.
Morris wanted to test something he had long been
interested in: the ability of typefaces to appear truth-
ful or not, and their ability to increase or diminish
the credulity of text.

His experiment – crude, erratic and certainly en-
tertaining – involved setting Deutsch's statement in six
different typefaces: Baskerville, Trebuchet, Georgia,
Helvetica, Computer Modern and Comic Sans.
Would one typeface encourage his readers to answer
his questions in one way while another might show a
different response? And how would all six compare?

His typeface choice was designed to represent a broad range – from the most traditional (Baskerville) to the most associated with childhood and play (Comic Sans).

Morris drew inspiration for his experiment from the anecdotal findings of a Canadian university student named Phil Renaud who had noticed a peculiar thing with his essay marks (and then blogged about it). Renaud had suddenly begun to get much improved grades on his work, even though he didn't believe it was notably better than his earlier work. There may have been many reasons for this, of course, not least an improvement from experience and expertise. But there was also something else. Out of fifty-two essays, eleven were in Times New Roman, eighteen in Trebuchet MS, and the remaining twenty-three in Georgia. His earlier papers in Trebuchet MS had averaged B-, the ones in Times New Roman had averaged A-, but the most recent ones in Georgia had averaged A.

To examine whether and how such a thing would hold up in a larger survey, Errol Morris had enlisted the support of a game developer to randomise the alternating online text in the *New York Times* and a psychologist to analyse the results. The results were satisfying and apparently conclusive, even allowing for margins of statistical error.

'Is there a typeface that promotes, engenders a *belief* that a sentence is true?' Morris asked his readers a few weeks after the initial survey. 'Or at least nudges us in that direction? And indeed there is. It is Baskerville.'

The results involved graphs, which made it look scholarly, and rather better thought-out than it was. There were graphs with numerical totals and graphs with weighted comparisons, and then mathematical p-values and F-statistics to break down the results and eliminate or highlight bias and the possibility of randomness and potential error. The overriding signal was that more respondents – 4,703 – agreed with the 'safety' comments from David Deutsch when the text was in Baskerville than when it was in Comic Sans (4,523). Of these, 1,669 *strongly* agreed with the statement in Baskerville, compared to 1,567 in Comic Sans. Of those who disagreed, a reverse pattern was visible: 2,985 disagreed when in Comic Sans, 2,833 when in Baskerville. Not exactly a dramatic contrast, but enough for people to come to a not wholly unexpected conclusion (although the reaction may have been more anti-Comic Sans than pro-Baskerville). Overall, 39 per cent of the test-takers were pessimists and found fault with Deutsch;

61 per cent were optimists and agreed with him.*

David Dunning, the psychologist at Cornell, concluded that 'Baskerville is different from the rest. I'd call it a 1.5% advantage, in that that's how much higher agreement is with it relative to the average of the other fonts. That advantage may seem small, but if that was a bump up in sales figures, many online companies would kill for it.'

Dunning had no particular background in type, and apparently not much prior interest. He found the fact that font matters at all 'a wonderment'. Baskerville 'seems to be *the king of fonts*,' he emailed Morris. 'I pushed and pulled at the data and threw nasty criteria at it. But it is clear in the data that Baskerville is different from the other fonts in terms of the response it is soliciting. Now, it may seem small but it is *impressive*.'

Morris replied that he had guessed that either Georgia or Computer Modern would have been the most trusted, 'something that has the imprimatur of,

* The results of the experiment are, at time of writing, still available on the *New York Times*' website. There are many anomalies therein, not least the uncertain showing of Helvetica, that ubiquitous and seemingly 'neutral' type made in Switzerland in the 1950s, which appears to be both highly trustworthy in one analysis, rather untrustworthy in another, and somewhere in the middle elsewhere. If anything alerts you to the rather untrustworthy nature of this survey it should be this, but as I hope is apparent, I found it an intriguing exercise nonetheless, not least because it made a lot of readers think about type in a new way, or for the first time.

I don't know, truth — truthiness'.

'The word that comes to my mind,' Dunning wrote back, 'is *gravitas* …'

Dunning then admitted he was 'surprised that the damn thing worked at all', because the test was conducted in an uncontrolled environment. 'Who knows what's going on at the other end of a computer screen? Their kids could be screaming in the background for all we know. It could be two a.m. It could be two p.m. They've had their coffee. They haven't had their coffee …'

The fact that Errol Morris is a film-maker and not a type designer is exemplified in the delight he takes in his findings, and amplified by the quote with which he opened his report: 'The world is full of obvious things which nobody by any chance ever observes.' But this statement, uttered by Sherlock Holmes, is another slight misdirection. It's from Chapter 3 of *The Hound of the Baskervilles* (1902), a title which has no valid connection with the name of the type founder, spoken by a fictional character whom many people

still believe to be real.*

The response from readers to Morris's experiment (after the trick was revealed) was generally one of fascination, and the findings rippled out to other newspapers and radio talk shows ('Do *you* have a favourite type? Let us know!'). But some readers were suspicious of the findings, not least members of what may be loosely called the design community (one reader accused Morris of 'fontificating'). But even they must have been reassured by the level of mainstream interest shown in the psychology and application of type.

Among the more insightful critics, Gerald Moscato, a graphic designer and calligrapher in Illinois, remarked that the digital age had brought forth a great many Baskervilles from several different

* The closest the two Baskervilles get is when a publisher chooses to print Conan Doyle's story in Baskerville. One may reasonably ask what is being said by a publisher when they choose instead to print it in Times New Roman. There's a nice piece of symmetry in the novel. Examining a threatening note assembled from words torn from a newspaper ('As you value your life or your reason keep away from the moor'), Holmes immediately detects that the source is *The Times*. His audience, which includes Sir Henry Baskerville, are necessarily astonished. 'This is my special hobby,' Holmes explains. There is a great difference, he claims, between 'the leaded bourgeois type of a *Times* article and the slovenly print of an evening half-penny paper'. He finds 'The detection of types is one of the most elementary branches of knowledge to the special expert in crime, though I confess that once when I was very young I confused the *Leeds Mercury* with the *Western Morning News*.'

digital type foundries, Adobe, Monotype and ITC among them. The Baskerville in the dropdown menu on Apple computers was not necessarily the same one to be found on Dell or Acer machines. Besides, a reader viewing this experiment on a machine without the availability of Baskerville, Trebuchet MS or the

Baskerville Baskerville

Baskerville *Baskerville*

Baskerville **Baskerville**

Baskerville *Baskerville*

Baskerville **Baskerville**

Baskerville ***Baskerville***

The modern variations of Baskerville Original Pro.

others would automatically default to an alternative. 'To see the actual Baskerville would require finding the original metal font and *printing* it. Anytime anything is redesigned or reproduced, there are minor (or major) altered design characteristics.'

C.J. Eder from Idaho noted that of all the typefaces in the survey, Baskerville was the only one with a strong association with print, while the others, Helvetica rather excepted, were all created with the computer in mind. Frank Fusco from Florida believed there was a fair chance that readers would have been influenced by the typeface of the rest of the article, which was in Cheltenham; the more a type contrasted with it (i.e. Comic Sans), the less trusted it might be.

The most vociferous opposition came from the renowned typeface designer Erik Spiekermann. Emailing from his home in Berlin, he found the experiment ludicrously oversimplified. 'Testing one typeface that we're familiar with from books against a bunch of late arrivals that we only know from our computer screens is like generally testing horses against cars and declaring a Buick Regal the winner.' Spiekermann is responsible for the widely used digital types FFMeta and ITC Officina, as well as the founding of the digital type warehouse Fontshop. He reasoned that 'any classic typeface that has been

used for reading long text would have won, whether one of the many revivals of Caslon (18th century), Garamond (16th), Bembo (15th), Times (1931) or their newer cousins like Palatino (1952)'.

He has a point. A less diabolical experiment, and a far more intriguing one to those working in the graphic design industries, would be to pit Baskerville against its pre-digital rivals, against Caslon and Bembo and Times New Roman. Put Comic Sans into any mix and you'll get a reaction akin to putting Mentos into a bottle of Coke.

Spiekermann also repeated a clear truism of type: 'We read best what we read most and we trust what we're familiar with.'*

* I interviewed Spiekermann in Berlin in 2010 for my book *Just My Type*. He was full of strong opinions, and I remain grateful for his witty and vivid observations. 'Type has rhythm, just like music,' he told me in reference to a branding rethink he had conducted for the Berlin Philharmonic (and which he felt was now being spoilt by those who didn't understand his principles). 'It's like cooking – you can follow a recipe to the last gram, but if the love isn't there it's just flat and bland.' He had also redesigned the look of *The Economist*. But 'I never want anyone to pick it up and say, "What a cool typeface." I want them to say, "What a cool article." I don't design the notes – that's what writers do; I do the sound. And the sound has to be legible.' I'm not sure Baskerville would have agreed; he would have wanted a reader to admire both notes and sound.

Three years after this all began, Morris's work was given an official bound afterlife, an imprimatur from the design company Pentagram, which compiled all his thoughts into a handsomely designed 76-page book it sent to favoured clients, entitled *Hear All Ye People; Hearken O Earth!* The line comes from the Bible's Book of Micah, which prophesied the coming of Jesus. A full page from Baskerville's Bible with this proclamation appears inside Pentagram's book, alongside a similar impression from *Paradise Lost*, a giant Baskerville lower-case g, and some random witticisms and 'proverbs': 'I'd give my right arm to be ambidextrous.'

Most of the book is set in a modern digital rendering of Baskerville by the Czech graphic artist František Štorm called Baskerville Original, one of many versions available online. This choice at least pleased the influential type expert Stephen Coles, delighted that it 'added some authenticity' to the project 'by using the only digital Baskerville that comes anywhere close to Mr. Baskerville's original.' The sizes in this digital family emulated the physical design compensations of metal type, 'allowing headlines to be delicate and showy, while body text is open, sturdy, and readable. All other digital Baskervilles have only one size, often traced from the face of some mid-range size, making it too feeble for

text yet lacking the elegance of a titling face.'*

Errol Morris was interviewed by FastCoDesign online at the time of publication, and was asked whether the results of the experiment changed his own choice of typeface. 'Oh yes, I'm drinking my own Kool-Aid now. I used to write all of my manuscripts in Bembo. Now I write them in Baskerville.' He may have been kidding. Or he may have been telling the truth.

Perhaps the most surprising thing about Errol Morris's surprise experiment is that he should have been surprised by the results. The most sober part of the Pentagram book concerns Morris's own research into Baskerville, using many of the contemporary and later sketches and biographies I have also consulted for mine. Then he goes a little off-beam, suggesting, in the manner of Arthur Conan Doyle, that there may have been a 'Baskerville Curse' relating to the ill-fortune of his printing trade and the

* The book was part of a series, this one Pentagram Papers 44, designed by Michael Bierut and Jessica Svendsen. Stephen Coles's principle objection to the Morris experiment was in the headline it created. Rather than 'Baskerville is the most trustworthy typeface' Coles believed it should have been 'The typeface you choose can affect your reader's perception of truth.'

fate of his corpse. And at the end he turns fanciful: 'We have entered a new, unexpected landscape,' he proclaims. 'Could a typeface swing an election? Induce us to buy a new dinette set? Change some of our most deeply held and cherished beliefs? Indeed, we may be at the mercy of typefaces in ways that we are only dimly beginning to recognize.' Morris wondered, with more than a touch of overreaching glee, whether such an instinct could 'go back to the primordial soup'. He questioned whether 'a trilobite swimming in the mid-Cambrian ooze ... [would] have responded with enthusiasm to a sign written in Baskerville?'

The answer is no. But type has always had purpose. This is why tens of thousands of variations of the alphabet have appeared since the time of Gutenberg 650 years ago. Some of the intentions appear simple – legibility, beauty, accessibility – but some are rather more subtle, and deserve further scrutiny.

6. Q & A

Baskerville's alphabet contains several pleasing ways to distinguish his typeface from others. The open bowl of his g, the gently cupping and scythe-like tail of his Q. His lower-case e is both traditional and distinctive. It is three-quarters of a circle, with a high cross-stroke above the median line, a characteristic it shares with the much older Garamond. But the letter is rounder, thus making the closed crescent 'eye' of the letter less likely to be jammed up with ink. The larger bowl of the lower-case a is similarly advantaged, the internal space less squashed, its clarity evident.

Other characteristics – a marked definition between thin and thick strokes, a wide-bodied generosity towards his rounded letters while maintaining a straighter vertical stem for others, the slightly sharper angles and tapering serifs – would set a pattern. There is an openness and clarity to the words these letters make; their delicacy is vibrant, but only viable with the cleanest of printings. Yet we have little detailed evidence of what Baskerville himself intended for his type. Apart from his letters above to Robert Dodsley and his Preface to Milton, there are no

clues as to what he intended specifically for his g or his a or his Q beyond excellence. His skill and confidence as a designer stands, in the words of British historian G.M. Trevelyan, as 'self-poised, self-judged and self-approved', typical of the pre-revolutionary spirit of the age and replete with vigorous endeavour. Type has never been designed in a vacuum, and Baskerville's character dictated the shape of his characters: optimistic, lavish, strong.*

In Baskerville's view, his type was not only the most beautiful and exact, but the most suitable for the time in which he lived. He considered the shape of his letters to be expansionary, exciting, almost revolutionary. Today we would classify his type as either neoclassical or transitional, and both terms would have baffled its creator. Baskerville type was transitional (or even mid-transitional) in so far as it stood between the heavily Dutch old face of Caslon and the more modern look that succeeded it in Italy

* We will meet the typography scholar Beatrice Warde shortly, but for now it is just worth quoting her obvious but perfectly phrased observation that to criticise one letter in isolation – she uses the example of an h – 'would be as idle as to criticise one window of the façade of a house. Lower-case h is part of a word, and unless, for example, it forms a perfect and matter-of-fact connexion between the t which precedes it and the e which follows, it has no reason for existence. Type, then, must be studied in groups of words first of all, then by single words, and last of all by the structure of each letter; all type is not so much good as good for its purpose, whatever that may be.

and France, specifically the types of Giambattista
Bodoni and the Didot foundry. And it was neoclas-
sical in so far as it adhered to traditional Roman
forms under the influence of humanist penman-
ship. Physically, Baskerville and Bodoni would have
regarded their types neither as transitional nor
modern; they would have just been the newest and
(they hoped) universally regarded as best, much as
one might regard the latest, fastest laptop comput-
er. Besides, until the more commercial metal type
foundries of the nineteenth and twentieth centuries,
most printers would not keep a large stock of differ-
ent faces to compare; they bought the few best suited
to their needs and stuck with them. And when they
were done, they would most likely melt them down.

In 2015, the typeface designer and historian Craig
Eliason made a comparative study of four central
characteristics in Caslon, Baskerville and Bodoni.
Examining contrast, axis, stroke construction and
serif shape, he found the distinctions between the
three faces rather inexact and warned against over-
simplifying any classification of type. Because inspir-
ations may be unknown, even to the type designer
themselves, and because our historical survey relies

on a retrospective approach, one should be wary of too swiftly defining a type as transitional or modern or (later) grotesque or humanistic. Eliason's descriptions are arcane, marvellous and exacting. They point to the painstaking precision that concerns the workings of type, and the conversations that modern designers entertain in their consideration of every section of every letter. Certainly this applies to the digital age; Baskerville and his punchcutters would have struggled with similar issues with regard to serifs, ascenders and ligatures, albeit not with quite the same vocabulary.*

Three illustrations in no way exhaust Eliason's analysis. 'Compared to Caslon,' he writes, 'Baskerville's difference in weight is better described as a lighter design: its thins and thicks appear narrower than the corresponding parts in Caslon, but they remain in a similar proportion. For their part, Bodoni's late designs retain the thin thins of Baskerville but resume the thick thicks of Caslon, resulting in their oft-noted high contrast.'

With regard to axis (the angle at which the thickening strokes of a letter reach their thickest point

* The term 'transitional' was first popularised by D.B. Updike's *Printing Types: Their History, Forms and Use* in 1922, just before Baskerville was newly issued in a well-promoted version from Monotype. Eliason's discussion can be found at *Design Issues*, vol. 31, no. 5, Autumn 2015, MIT Press.

and the thinning strokes reach their thinnest point), most of Caslon's letters have a back-inclined axis, originating from right-handed handwriting with a broad-nibbed pen. Baskerville shares a more vertical axis with Bodoni. Take for example the lower left corner of the lower-case b. 'Where Caslon's slanted axis dictates a thickening, Baskerville and Bodoni bowls connect to the stem with a hairline.'

In the case of the serif, the small finishing strokes at the beginning or end of a letter, Caslon's are heavy and appear to grow out from the letter naturally, while Bodoni's are fine, almost wisp-like, seemingly applied as an afterthought. Baskerville's are far closer to his great English inspiration than to Bodoni, giving them a more triangular shape, at least until one examines his ascenders (say, the upward part of a lower-case b or d), which herald a sharper imagining in Italy.

Would Baskerville have turned (once more) in his grave at these comparisons? I rather think he would have embraced them. Eliason concludes that although his type in many cases does indeed supply a transitional stepping stone between the old style and the modern, some of the theory breaks down when one considers that Baskerville's type has influences older than Caslon's (seventeenth- and early eighteenth-century styles of handwriting) and

also a more modern one, the clinical, scientifical-
ly formulated letters designed for the Imprimerie
Royale, the printing office ordered by Louis XIV for
the Louvre in 1692. This royal commission worked
mathematically, drawing more with set-square and
grid to make a geometric-looking alphabet that
was cut – somewhat reluctantly one imagines – by
Philippe Grandjean. The idea that type could now
be constructed on these principles, rather than hand-
writing and nib that would lie at the root of
Baskerville's letters, was understandable, inspired by
the foundations of modern science and industry. As
Beatrice Warde observed, the microscope enabled a

Innovation

(Adobe Caslon)

Innovation

(Monotype Baskerville)

Innovation

(Monotype Bodoni)

whole new conception of what accuracy could mean. 'The seventeenth century started with alchemy and astrology; it ended with Newton and Descartes.' The 'Romain du Roi' that emerged at the Parisian court was a vague attempt to produce something ultimate, a text type that would supersede not only a reign but all attempts to modernise, adapt or improve it. We should be grateful that such a thing is now considered both a hubristic folly and nigh impossible.

Contemporary critics found Baskerville's letters both good and bad, and he was less well regarded in his own country than abroad. Almost all noted how his type was part of an innovative package, inseparable from his advances in a blacker ink, his novel smoothing pressing process and a glossier paper. Although he would print many engraved illustrations, particularly in his later years, he was keen for his type to be judged as art in itself, and he spaced his letters (in great primer size) with more leading and surrounding space on the page than was the custom, to the point where whole words – B U C O L I C A, G E O R G I C A ET AE N E I S on the title page of his Virgil – would almost fall apart.*

* In his comprehensive biography of William Caslon, Johnson Ball observed that his excessive title spacing, particularly of his italics, often made his letters look 'like victims of malnutrition'.

His fellow eighteenth-century type founder Pierre-Simon Fournier observed how Baskerville 'has spared neither pains nor expense to bring [his type] to the utmost pitch of perfection. The letters are cut with great daring and the italic is the best to be found in any English foundry, but the roman is a little too wide.'

A century ago, the revered American type historian D.B. Updike detected 'a slight touch of over-delicacy' in Baskerville's type, regarding it 'not as good as Caslon's' while acknowledging its considerable influence. He holds a particular distaste for Baskerville's four-volume printing of the works of Joseph Addison (1761), the letters carrying 'a monotonous roundness', and its ascenders and descenders (the lower-case b or d; the lower-case g and p) lack sufficient height or depth. The overabundance of italic is 'gray in colour and wiry in line, and annoyingly condensed in shape'. He has far better things to say about the letters in some of Baskerville's other, smaller books ('the imposition is elegant ... the type clear'), and he notes how the jealousy of other printers 'abused his type'. And yet they all lack the 'homely charm' of Caslon, Updike believes, too closely betraying their origin from the hand of a calligrapher. Accordingly, they were 'too even, too perfect, too "genteel", and so they charmed too

apparently and artfully – with a kind of … sterile refinement'.

Caslon's biographer Johnson Ball writes that a comparison with Caslon should only be taken so far. Caslon was a dedicated punchcutter, whereas Baskerville only dabbled. Moreover, while Caslon created a valuable Arabic, Greek, Hebrew and Armenian type, Baskerville's efforts in anything but his native roman were widely considered disastrous, causing typography scholars and fellow punchcutters and printers to proclaim his Greek letters 'not good ones' (William Bowyer), 'like no Greek characters I have ever seen', (Thomas Dibdin), 'stiff and cramped' (Johnson Ball), and plainly 'execrable' (Edward Rowe Mores). There was clearly also a show of envy here, and disdain: Baskerville's status as a provincial self-taught amateur, and an apostate too, would hardly endear him to traditionalists.*

In his comparisons of type forms from the fifteenth century to the present, the type historian Alan Bartram finds in Baskerville 'the gravity and serenity of Bath terraces, the elegance and craftsmanship of Hepplewhite or Chippendale'. When

* More recently, Baskerville's Greek has been reappraised by the typography professor Gerry Leonidas, who has found many more favourable aspects. See Archer-Parré, Caroline and Dick, Malcolm (eds), *John Baskerville: Art and Industry of the Enlightenment* (Liverpool University Press, 2017).

used for classical texts it made earlier examples seem congested, and it suited long periods of reading. It was both revolutionary and unobtrusive; its influence would only begin to be fully appreciated in England 175 years after its creation.

In his worldly *The Elements of Typographic Style*, the Canadian poet and linguist Robert Bringhurst praises Baskerville's 'thoroughgoing symmetry and delicate finish', and its 'homey but fussy buff and polish'. With Baskerville and Caslon in mind, he notes how 'typography, like other arts, preys on its own past. It can do so with the callousness of a grave robber, or with the piety of unquestioning ancestor worship.' Baskerville perhaps did both. Bringhurst connects Baskerville's popularity with Benjamin Franklin to the properties the form of his letters share with the style of American architecture. 'They are purely and imperturbably Neoclassical as the Capitol Building, the White House and many other federal and state edifice.' Another modern commentator finds a more cinematic parallel. Baskerville was the Cary Grant of alphabets – sophisticated, suave and witty.*

But the most illuminating and entertaining analysis of Baskerville is almost a hundred years old. In

* See Mark J. Bishop's analysis of Baskerville with regard to its digital use. Despite Benjamin Franklin's admiration for his friend, the first printed version of the American Declaration of Independence used Caslon.

1927 an unsigned essay in the *Monotype Recorder* was as much a sales pitch as a critique, and no wonder: it was printed in Baskerville, and written by Beatrice Warde, the magazine's American editor and soon-to-be Monotype's publicity director. The company had issued a new version of the type based on the original punches in 1923, and Warde explained why it was already proving so popular with printers. She suggested that Baskerville was not merely a transitional compromise between those other reliable roman book type choices Old Face and Modern, 'any more than to be twenty-five is a compromise between being twenty and thirty'. Rather, Baskerville was 'remarkably engaging' and possessed of 'a unique charm'. Just as it proved popular in its day (at least abroad), there was every indication, she hoped, that 'its permanent adoption as a standard face (and perhaps *the* standard face) will date from our own day ... in regaining Baskerville we have found what may prove to be the one perfect vehicle for the English language.'*

* Beatrice Warde's position as a woman in the industry – and one with such a strong and original voice – made her a rare specimen. It was a search for greater acceptance that led her to adopt the pseudonym 'Paul Beaujon' for many of her articles. For more on her role at Monotype see the first book in this series, *Albertus*. The letters of Monotype Baskerville are modelled on Baskerville's printing of Terrence's *Comoediae* of 1772. It has a slightly finer and cleaner look than the original.

Warde was not only a great interpreter of typo-graphic style, but also a skilled educator. Her essay on Baskerville was a precursor to 'Printing Should Be Invisible', her famous speech of 1930 in which she invoked the concept of the crystal goblet: a wine connoisseur will value this vessel more than a golden chalice or something similarly opaque; it is what is being drunk (or in type's case read) that counts, and the less one is aware of the vessel the better. In her consideration of Baskerville she employs another analogy from an unnamed colleague: we should 're-mind the typefounder that we ask of type only what we ask of a phonograph record: that it should trick us into forgetting that it is there'.

Warde believed that the key to Baskerville's type lay in his experience as a writing-master. 'Once you have formed letters carefully with a pen ... the shape of types will always be real and alive to you.

A man who has learned to play the piano can generally be brought out of bed, as one lazy musician was, by striking an unresolved seventh on the piano and leaving it to worry at his brain until the completing chord is played. And similarly one who has learned what a good capital M looks like will feel an almost physical pain on seeing one in which the middle strokes do not come down to

the base line. You will find him drawing Rs and
lower-case g's on the back of his menu instead of
the profiles that the rest of us draw; and with every
stroke he will feel again the awed wonder of the
initiate at that constant and beautiful mystery, the
alphabet. There is every reason to abandon the
trade of writing-master if more money is to be
made elsewhere; but there is no hope at all
of ceasing to draw those Rs and to wonder
about them.

The design of Baskerville's letters were products of
the way he taught writing and the angle of his pen,
and it was this that rendered them new (this is par-
ticularly visible in the italic fonts influenced by his
'roundhand' manuscript style). Caslon and its Old
Face predecessors were popular at a time when it
was traditional to hold a pen less vertically than the
angle favoured by Baskerville, the new style enabling
finer, more sparkling hair-strokes and a greater con-
trast between thick lines and thin. In the mid-1920s
Beatrice Warde thought it necessary to remind her
readers that the penmanship favoured by Baskerville
was very different from the style prevalent 175 years
before, which she labelled 'exquisite, difficult and
perhaps precious'. The non-calligraphers among us
today might find it hard to envisage the pleasures

and frustrations of an ink-dipped nib at all, at whatever angle, and in its place we have the less difficult and less precious dropdown font menu on our computer.

Warde detects one more innovation in the actual shape of Baskerville's letters: a general broadening of proportion (as opposed to just width). This generosity also made it an ideal text type at a small size, a kindness to the reader's eyes. This is again best seen by comparison with other faces, and by a grouping of words to judge an alphabet's 'combinability'. By placing the same line in Baskerville next to Caslon:

The quick brown fox jumps over the lazy dog

(Big Caslon)

The quick brown fox jumps over the lazy dog

(Baskerville)

we see, no less in its cleaner modern digital state, the seamless easiness and 'featureless transparency' of Baskerville over its predecessor. It is clearly more

compact and consistent too, and in Warde's words, 'there is perhaps no type in existence which welds together into words so inevitably'.*

We have seen how, despite all these qualities, Baskerville's letters took a while to please a readership, certainly in Britain. And it is true that it only became truly accepted after its Monotype reissue in the 1920s, after which it became as much a part of the textual landscape as Times New Roman, Verdana, Georgia and Arial; for a type to be truly successful we must forget about it, and for this we must be used to it.

But we end this section in a spot of bother. What happens *before* we are used to it? What happens when a typeface is so unfamiliar that it is positively feared? One answer lies in a famous letter Baskerville received from Benjamin Franklin in or around 1760.

* 'The Quick Brown Fox …' has been a template at least since 1885, used initially not for type display but as a way of improving or demonstrating handwriting; a famous pangram, it uses all the letters of the Roman alphabet. But individual foundries, both metal and digital, have favoured their own way of demonstrating a type's most original and comparable features: Monotype favours 'Stay home. Reimagine the ymca choreography with bcdfjklquvxz' as well as 'Stay home, and the sphinx of black quartz who judges vows will say wow'. Many European digital foundries go for the word 'Hamburgevons' (sometimes 'Hamburgefonstiv' or Hamburgefons). Showing off its wares online, I Love Typography chooses 'So we beat on, boats against the current' from the last line of *The Great Gatsby*. There is more on the various modern versions of Baskerville at the end of this book.

We have seen how supportive Franklin had been towards the printer (he visited his foundry in 1758, and perhaps the following year as well, buying japanware and several books for himself, friends and the library at Harvard), but his greatest gift was an account of a trick he played on a rather less supportive bibliophile who also fancied himself a 'connoisseur' of type:

Dear Sir,

Let me give you a pleasant Instance of the Prejudice some have entertained against your Work. Soon after I returned, discoursing with a Gentleman concerning the Artists of Birmingham, he said you would be a Means of blinding all the Readers in the Nation; for the Strokes of your Letters, being too thin and narrow, hurt the Eye, and he could never read a Line of them without Pain. I thought, said I, you were going to complain of the Gloss on the Paper, some object to. No, no, says he, I have heard that mentioned; but it is not that—it is in the Form and Cut of the Letters themselves: They have not that natural and easy Proportion between the Height and Thickness of the Stroke which makes the common Printing so much the more comfortable to the Eye.— You see this Gentleman was a Connoisseur. In vain I endeavoured to support your Character

against the Charge: He knew what he felt, and
could see the Reason of it, and several other
Gentlemen among his Friends had made the same
Observation, &c.—

Franklin then revealed his prank. When the pompous
expert had called on him to continue his complaint,
Baskerville's friend tried the old switcheroo. Instead
of a specimen from Birmingham he produced one
from Caslon.

He readily undertook it, and went over the several
Founts, showing me every where what he thought
Instances of that Disproportion; and declared,
that he could not then read the Specimen without
feeling very strongly the Pain he had mentioned
to me. I spared him that Time the Confusion of
being told, that these were the Types he had been
reading all his Life with so much Ease to his Eyes;
the Types his adored Newton is printed with, on
which he has pored not a little; nay, the very Types
his own Book is printed with, for he is himself
an Author, and yet never discovered this painful
Disproportion in them, till he thought they were
yours.

 I am, &c.

Baskerville could find no finer or more complete vindication of his work. In 1763 he used the letter – possibly without Franklin's approval (he was back in Philadelphia by then, mapping postal routes in the colonies) – in several newspaper adverts promoting the publication of his new Bible and other works, all obtainable at a shop in London's Strand. Readers of the *General Evening Post*, the *London Chronicle* and the *British Evening Post* all learnt what a chump looked like, and how, if they would only buy his Bible, Milton and Horace, they would avoid being judged one themselves.

7. THE ART OF ANGLING

Alas, the advertisements weren't enough. His Bible didn't sell, or at least not enough to repay the anguish involved in its creation.

Baskerville had been planning the book for three years, and it isn't difficult to see where the time and care had gone. The scale of the undertaking was huge. The elaborate title page, over which Baskerville wrote that he had 'taken great pains' to make 'striking', heralded its glories in several sizes of roman

and italic, and a great deal of coiled and fanciful line decorations, going well beyond standard swash lettering, with the first and fifth lines enmeshed in something resembling filigree ironwork:*

Baskerville's price for unbound sheets was four guineas. Perhaps it was overpriced; perhaps it wasn't marketed well, or he overestimated the demand beyond his initial subscribers; perhaps for all of these reasons his magnificent Bible failed to sell. Of the 1,250 copies printed, 556 were remaindered and sold to a London bookseller at less than half the price; in 1771, eight years after Baskerville's publication, the sheets were selling at the London bookselling firm R. Baldwin for three guineas.

Baskerville had been obliged to produce his masterwork in Cambridge, the printing of the Bible permissible only under a special royal licence. Three years earlier he had printed the *Book of Common Prayer* under a similar arrangement, having become

* A swash letter always makes a point, usually in commanding more space and attention, often with a lavish curl or other unnecessary (but often beautiful) attachment. Not everyone approved. Perhaps overproud of his achievement, and overcome with ambition, the title page can appear a little punch-drunk. Reviewing an exhibition of Baskerville's publications at Yale in 1937 for the *Library Gazette*, Carl Purington Rollins judged the title page 'a huddle of letters, mostly ill at ease'.

'The best made books in England': the Baskerville Bible of 1763.

'Printer to the University' at the end of 1758 after agreeing to pay a fee for the privilege.*

Baskerville's correspondence reveals how he believed himself badly treated by rival printers and the London book trade, and one letter in particular, written in 1762 to the third earl of Bute, first lord of the Treasury, owner of several of Baskerville's books, shows the extent of his desperation. It is nothing less than a begging note. He complained of 'the expensive inconvenience of setting up a compleat Printing House' in Cambridge (he transported two entire presses from Birmingham), and 'the double Carriage of Paper to & from Cambridge and afterwards to London'. Prior to that, in an equally self-pitying tone, he estimated he had spent 'above 1000 Pound before I returned a shilling' on establishing his works in Birmingham. Referring to his first edition of the *Book of Common Prayer*, 'I was a loser, the Price being fixed too low to account for the extraordinary Expence.'

Other tales of woe followed: he wrote how earlier plans to print Milton had met with cartel-like

* Baskerville called it a 'hard condition': he was obliged to pay the university £20 for every thousand copies printed of the *Book of Common Prayer*. At the foot of the title page of the Bible I examined in Birmingham, in tiny italics, sat the phrase '*cum privilegio*', denoting the granting of this licence.

opposition from London printers, and how the 'pat-
entee' at the University of Cambridge had proposed
to print a Bible to compete with his at half the price.
'It is surely a particular hardship,' he continued to the
earl, 'that I should not get Bread in my own Country
(and it's too late to go abroad) after having acquired
the Reputation of excelling in the most useful Art
known to Mankind.' He found this doubly unfair
as any old 'Player, Dancer, Fidler' lived in affluence,
and had no trouble saving 'a Fortune'.

Baskerville's complaints did have substance.
Despite the quality of his printing and its worthy
acclaim (and possibly because of both), his com-
petitors attempted to crowd him out; he mentions
a little exceptional support from Jacob Tonson, the
descendant of a long-established bookselling firm in
the Strand. He now requested a rather different type
of patronage from the earl of Bute, enclosing print-
ing specimens of his Bible he wished to be passed
on to King George III. They were so much better,
he insisted, than previous editions subjected to
'mercenary Prostitution and Abuse' by exploitative
printers using 'a worse Paper than any other the
meanest Book that can be found in Britain'. He also
sent samples of a set of letters he hoped might be
approved by the Royal Mint, initially for the guinea
coin. 'If approved I shall readily furnish all the Sizes

of the Letters for the whole Coinage; which I hope may add some Beauty; and make it more difficult to counterfeit the Currency.'

His request yielded little success. We do not have Bute's response, but we may assume from Baskerville's subsequent correspondence that he did not receive patronage from the Royal Mint. So Baskerville tried a new appeal a few years later. In 1762 he wrote to the writer and Whig politician Horace Walpole, again sending a specimen of his work and using almost the identical phrases he had used in his plea to the Earl of Bute. Baskerville was now in a terrible way. He had presumed that if he worked dutifully and excelled in his new calling he would find his life easy 'or at least give me Bread. But Alas! In both I was mistaken.' He again complained of the 'particular hardship' of not getting 'Bread' in his own Country, and again compared the impoverishment brought on by the most useful art known to mankind with what he saw as the easy and lucrative life of an actor or musician. He revealed that his Bible would cost him almost £2,000 to produce, and complained of 'such shackles as greatly hurt me' imposed by the University.

By now he had had enough, and wrote he had resolved to sell 'the whole scheme' to the courts of Russia or Denmark. He explained that an

(unnamed) friend of his had told him it would be 'a national Reproach' to England should he do so, and so now appealed for a grant from Parliament to save his loss-making efforts. He noted that the government had recently given 'a handsome premium' to an (again unnamed) 'quack medicine', and he now hoped that 'some Regard' would be paid to him by the House of Commons. Without 'the least aggravation' he now humbly called upon Walpole, 'a lover of the Arts', for encouragement and patronage. 'To whom can I apply for protection, but the Great ...?'

Alas, no such generosity was forthcoming. Despite his gloom, and serious attempts to sell his presses and all their attendant paraphernalia, Baskerville kept his printing works open for another eleven years, branching out to include more modern and more commercial works such as Charles Bowlker's *The Art of Angling*.* In all he printed more than fifty books, and many of them would be the finest specimens in any eighteenth-century library.

* A plan to sell everything to the French ambassador, the Duc de Nivernois, for £8,000 in 1767 did not proceed, and he wrote to Benjamin Franklin in Paris to try to rescue it by reducing his price to £6,000. 'Let the reason of my parting with it be the death of my son and intended successor.' The reduced offer also fell through. During these negotiations, Baskerville licensed his works to his foreman Robert Martin, who made his own copy of the Bible and printed a nine-volume edition of Shakespeare, among other books.

Or indeed any modern library at an old university whose entrance is just below a campus branch of Starbucks. When I examined a further sampling of Baskerville's work at Birmingham University's Cadbury Research Library in January 2023, I was struck by one overriding sensation: wonder. This is work of such high aesthetic quality, and of such painstaking endeavour. The textual errors that marred some of his earliest works seem both inevitable and forgivable given the scope and ambition of what came later. The collection here consists of almost 150 books printed at the Baskerville works in Birmingham or Cambridge, the range of content dazzling in itself.

And the size too. I examined a dozen books, half of which I had requested, the other half suggested by the librarians. Of the latter, *An Account of the Expedition to the West Indies* by Captain Gardiner of the King's Royal Musketeers (1762), was unexpectedly exciting for its pull-out engravings of 'Martinico' and 'Guadelupe'. Then there was the three-volume *Characteristicks of Men, Manners, Opinions, Times* by Anthony, Earl of Shaftesbury (1773), also with engravings, and many letters and much advice. (This would now equate to a fine Christmassy till-side book, boutique and diversionary. One of the copies I handled could never have been read, for its pages

were uncut, the book less the intended multilayered compendium than a segmented orange.*

But the big stars were the biggest books, the Bible and *The Anatomy of the Human Gravid Uterus* by William Hunter, both rendered with supreme, nuanced authority in his exquisite neoclassical type. Hunter, we are told on the frontispiece, was 'Physician Extraordinary to the Queen, Professor of Anatomy in the Royal Academy, and Fellow of the Royal and Antiquarian Societies'. Most extraordinary was the size of the volume, some 62cm × 45cm, and the impact, even now, of its groundbreaking, explicitly detailed copperplate engravings by Jan van Rymsdyk.

In the preface, Hunter explained how he was able to analyse his subject matter in such detail. 'A woman died suddenly, when very near the end of her pregnancy; the body was procured before any insensible putrefaction had begun; the season of the year was favourable to dissection; the injection of blood

* The full title of the first volume: *An Account of the Expedition to the West Indies, Against Martinico, With the Reduction of Guadelupe, And other the Leeward Islands; subject to the French King, 1759.* The text, in both English and French, was dedicated by Baskerville to Queen Charlotte. It took the form of a journal, rather pedestrian in tone: 'November 13. The Berwick about three o'Clock in the Afternoon appeared off Plymouth with a Dutch Ensign flying at her Main-top-gallant-mast Head, upon which Captain Shuldham in the Panther made the Signal to weigh.'

vessels proved successful; a very able painter, in this way, was found; every part was examined in the most public manner, and the truth well authenticated.'

And he explained why he chose his printer: 'The additional expense of Mr Baskerville's art was not incurred for the sake of elegance alone; but principally for the advantage of his paper and ink, which render a leaf of his Press-Work an excellent preservative of the plates between which it is placed.'

His intentions chimed well with Baskerville's proclamation issued many years before in his Preface to *Paradise Lost*: 'It is not my desire to print many books; but such only, as are books of *Consequence*, of *intrinsic merit*, or *established reputation*, and which the public may be pleased to see in an elegant dress.' The italics are his own. Printed in 1774, Hunter's *Anatomy* was Baskerville's last book, his last triumph.

8. A MOVEABLE TYPE

Nothing in Baskerville's life became him like the leaving of it.

On 19 December 1925, readers of the *Birmingham Evening Despatch* were introduced to a new regular

feature: Midland Celebrities. 'Birmingham has had connected with it more celebrities than any other centre ... in the country,' the newspaper claimed dubiously. The first in the series featured John Baskerville, 'The Man Who Was Buried Thrice'. He had been dead for 150 years, but as the star of Midland Celebrities he was still dazzlingly alive. The author of the story, W.H. Bush, ran through his career, from the teaching to the japanning to the printing, and then he alighted gleefully on his will, burial and what happened next.

His will was 'character revealing in almost every line', showing both 'solid virtues as a husband' and a 'nobility of temperament'; he bequeathed sums even to those 'who had been foremost in vilifying him for his religious views and loudest in their laughter at his dandified appearance'. Bush then tracked Baskerville's poor corpse over hill and dale. He was buried as requested beneath a conical structure in his own grounds. But then industry revolutionised everything, 'and the ever-growing pile of bricks and mortar that was Birmingham devoured the countryside'. After about fifty years or so a canal needed a new side-stream, and the newly cut land exposed Baskerville's leaden casket, which was then brought to the surface. Debate followed: what to do with him now? 'Our civic forefathers were too busy to bother

about a man who was no longer capable of making money,' W.H. Bush concluded, so his open coffin was brought to the shopfront of a plumber and glazier on Colmore Row, just opposite the train station. Baskerville then lay there for about three years, an unusual tourist attraction requiring an entrance fee. Amateur artists sketched the scene, tourists snipped at his shroud, 'and the needy scum of the town crept in to steal the teeth'. And then his body disappeared.

Some seventy years later, according to the *Despatch*, which brings us to the end of the nineteenth century, around the time Bram Stoker began working on *Dracula*, (you can see how this story might gather steam with each telling), 'people arose who cried loudly that it was a scandal that the town that had gained so much in prestige from Baskerville should not be able to point to his last resting place'. Amid the searching, a breakthrough: a bricked-up vault in the catacombs of Christ Church burial grounds at the corner of New Street was found to have no inscription plate or documented record. A curious clan of clergy, antiquarians and newspaper editors assembled around it to remove the bricks and have a look. The catacomb contained a coffin with a lid that had been soldered on with printer's casting lead. Inside lay our man, his skull and bones matching the sketches made when he was last on view.

As gothic demands, the tomb raid was conducted by candlelight in the 'dark, damp' air. The newly opened coffin contained a glazier's knife.

The *Evening Despatch* enjoyed not just the macabre but also the moralistic. The news column alongside its Baskerville story reported a reduction in wife-beating after prohibition had been introduced in India. In Baskerville's case the moral was simple: despite his resistance to a traditional Christian burial, he still ended up on holy ground (the result, it was believed, of a local solicitor taking pity on his soul, and stealing his body to place him in a vault he had reserved for himself). Baskerville was put back in the catacombs after the examination, and the vault was sealed up once more. The kerfuffle stirred national headlines and a question in Parliament, the Home Secretary H.H. Asquith being asked whether the exhumation was criminal. Yes, he reasoned, illegal exhumations *are* illegal, but in this case the whole Baskerville scenario seemed fairly unique, and unlikely to encourage others, so he would let the matter rest.

Which is more than can be said for poor Baskerville, for in 1901 he was moved again. Christ Church was considered surplus to requirements, and the bodies in the catacombs (six hundred by one account) were transferred to Warstone Lane

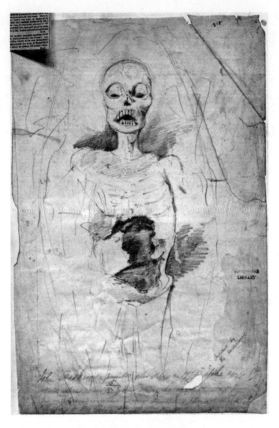

*All that remains: a sketch of his corpse in 1829 by
Thomas Underwood.*

Cemetery in the Jewellery Quarter. And there, W.H. Bush announced in 1925, his body still resides, and 'it is to be doubted if one person in ten thousand can point to it'. (A visitor on a grey drizzly afternoon in January 2023 can point to it in a general way, the untended crescent of tiered tombs rather than Baskerville himself.)

The *Evening Despatch* wasn't the first or last to tell the story. In 1935, the Birmingham *Sunday Mercury* reprinted the account word for word, while in 1956 the *Birmingham Post* informed its readers that, after Baskerville's departure from Easy Hill when the canal arrived, 'for the next eight years his body in its leaden coffin was left about in a warehouse'.

In 1964, the *Sunday Mercury* had another, more macabre, take on the story for its series The Spooky Midlands. Here was new information, and probably new imagination. The principal cause of Baskerville's notoriety was no longer as an expert type founder and printer, but as Birmingham's former high bailiff, a post he held from 1761. This time around, the warehouse where Baskerville lay concealed for eight years was owned by an iron merchant named Thomas Gibson, the same man who had constructed 'canal wharves' at his home and had dug him up in the first place. By the time he was displayed in the glazier's shop the admission fee varied, without

any clear reason, from one penny to one guinea. Baskerville's body had by now acquired a curse, or at the very least a poisonous miasma: the *Mercury*'s author, Vivian Bird, had dug up another telling from *Aris's Birmingham Gazette* from 1821 which had noted 'an exceedingly offensive effluvia strongly resembling decayed cheese', and quoted the artist Thomas Underwood's belief that a surgeon in Newhall Street tore a piece from the white linen shroud wrapping Baskerville's body, 'which he incautiously put into his coat pocket, and died in a few days.'

A further account may be found in a short BBC radio play by Neville Brandon Watts broadcast from Birmingham's Midland Home Service at the end of December 1947. *Hic Jacet: the Corpse in the Crescent* has yet another subtitle on its typed script: A Macabre Story. The copy I consulted at the Cadbury Research Library was once the property of the actor Norman Painting, who played the Reader (three years before he became Phil Archer in *The Archers*, a part he inhabited for fifty-nine years). No copy of the recording exists, and Painting's copy is covered in edits and directions, some of it in red pencil, to the extent that it is not easy to detect what was broadcast and what was cut.

'This is the story of John Baskerville,' the Reader begins, 'one of Birmingham's most remarkable sons,

who lived in a large house in extensive grounds ... he used to travel about in a highly ornate kind of chariot drawn by four white geldings. However, he was a very clever engraver and designer, and Baskerville type, founded by him, is still widely used and highly thought of.'

But now John Baskerville is almost seventy, the play imagines, and so he sends for a lawyer named Brett to officiate his will. Before the witnesses are called, there is a little biographical business for the listener – a bit on japanning, a bit on how costly the printing has been ('Nobody'll buy 'em, Brett'). Much of this passage appears to have been cut, including lawyer Brett's announcement that he was a big Baskerville fan, having already bought his Virgil, his Milton and his Bible. A fine investment, Baskerville replies. 'My books are the best made books in England, and they'll still be so a hundred years hence.' Unlike the person who made them: 'Well, at best he's just a box of tranklements [a steely local word; odds and ends] and long before a hundred years one of 'em cracks or bends or breaks – and there's an end of him.'

Most of the play is concerned with the subsequent burial, journey and display of Baskerville's body. At one point, the plumber Job Marston plans to show the corpse for profit:

Customer 4: I've come to see your peep show.

Marston: Twopence. Round this side. Mind the step.

Customer 4: Well! I never saw the like before and
I never will again. I've got a pair of scissors in
my pocket. Could I have a bit of the shroud for a
keepsake?

Marston: Fourpence extra.

Customer 4: Here it is.
[Chink of coin. Fade. MUSIC]

The play ends with Baskerville being loaded onto a
cart and pulled to Warstone Lane by a horse named
Boxer, with a gentle fade-out on the horse's hoofs.
And after that it was *Monday Night at Eight* with the
popular Monday Night Accumulator and 'singing
introducers' Bette Roberts and Dick James.

In 2022, Dr Caroline Archer-Parré, an expert in
eighteenth-century printing, published the latest
and most complete forensic analysis of Baskerville's
post-life life in the journal *Midland History*. She did

some accounting: in all, Baskerville's body had been moved eight times. She paid close attention to his 1,500-word will, the longest extant document we have from him, revealing both his character and beliefs, confirming him as a free-thinker. It is 'carefully crafted and consciously theatrical,' Archer-Parré writes, addressing 'not only its immediate audience but also audiences far into the unknown future.' She believes that Beatrice Warde's broadside 'This Is a Printing Office' applies well: acutely aware of the power of the printed word, Baskerville knew his would travel widely, 'not to perish on waves of sound, not to vary with the writer's hand / but fixed in time, having been verified by proof'.*

His will divided his spoils in a conventional way. His estate was valued at £12,560, around £2 million today; despite his struggles to maintain a profit from printing, his japanning had established his wealth beyond risk; it may also be that his accounts from his book publishing were not as parlous as his pleas to the earl of Bute and Horace Walpole had suggested. His wife Sarah benefitted from his division most, inheriting his entire Easy Hill estate and printing equipment, but he also gave generous gifts to her

* Since its inception at Monotype in 1932, Warde's treatise would have been set in Baskerville hundreds of times. For a fuller exploration see *Albertus*, the first book in this series.

daughter from her first marriage and to nieces and other family and friends. His generosity favoured women in particular. He left £500 to the Protestant Dissenting Charity School for underprivileged girls.

Baskerville saw nothing amiss with avenging those he believed had wronged him. He had once been accused of unsettled debts, and attacked Martha Ryland, for example, the wife of the industrialist John Ryland, for 'unprovoked, petulant malice and spleen and abusive treatment'. Others received what they would have regarded as paltry sums, as 'they will endeavour to traduce my memory as they have already done my character'. Perhaps it says something for Baskerville's own character that he still offered a token, a mild appeasement, rather than ignore them entirely.

Dr Archer-Parré finds Baskerville's will 'warm and compassionate on the one hand – angry and pitiless on the other'. The document was a personal and political performance, a last word on his singular worldview and religious nonconformism.

Here Baskerville let rip. He expressed his 'hearty contempt of all superstition, the farce of consecrated ground, the Irish barbarism of "sure and certain hopes".' He considered the Book of Revelation 'to be the most impudent abuse of common sense which ever was invented to befool mankind'. He believed

the moral code he had maintained throughout his life would now be dishonoured:

> I expect some shrewd remark on this my declaration by the ignorant and bigoted who are taught to believe that morality (by which I understand all the duties a man owes to God and his fellow creatures) is not sufficient to entitle him to divine favour without professing to believe as they call it certain absurd doctrines & mysteries about which they have no more conception than a horse.

The first newspaper accounts of his will omitted this bitterness, such was the fear of upset. And when his views were finally printed in full, those who felt differently might also have felt his rotting corpse deserved nothing more than its restless fate.

9. COMING HOME

The afterlife of Baskerville's type has proved as restless as his bones.

In October 1775, Georg Christoph Lichtenberg, professor of physics at Göttingen University, arrived

at Easy Hill hoping to find Baskerville in good spirits. 'Only on my arrival did I learn that he was buried more than six months ago,' he wrote to his publisher friend Hans Dieterich:

> I waited on his widow, an excellent woman … she gave me six samples of her specimens of type and quoted the prices per pound … If I or anyone else in Germany wish to purchase type, she is always willing to send it post free to London as soon as I communicate with her, which is no trifle in this expensive country. Although she was dressed very nicely in black silk, she accompanied me herself into all the most dirty nooks of the type foundry. I saw the punches and matrices for all the elegant letters which we have so often admired …

Lichtenberg reported that Sarah Baskerville was willing to part with everything he saw that day – not only the printing equipment but all punches and matrices too – for £4,000, but had not yet advertised anything publicly. 'What a chance, if only one had the money!'

Sarah then changed her mind, and in 1776 arranged an auction for the printing machinery only. The details of the sale are not known, but a year later she agreed to sell Baskerville types too. 'She

hopes,' *Aris's Birmingham Gazette* reported, that 'the acknowledged Partiality of the World, in regard to the peculiar beauty of Mr. Baskerville's Types in the Works he has published, will render it quite unnecessary here to say any Thing to recommend them.'

But it took almost three years for a sale to go through, and it was not good news for the British reader. The buyer was the French playwright and diplomat Pierre-Augustin Caron de Beaumarchais, who intended to use the type to print a seventy-volume edition of the works of Voltaire. But Paris was only the first port of call of many.

De Beaumarchais is best remembered today for two things: a chintzy hotel named after him in Le Marais district of Paris, and his plays *Le Barbier de Séville* and *Le Mariage de Figaro*. During his lifetime he was a spy, revolutionary and gunrunner, and his plans for Voltaire were typically seditious. Unable to print in France, where Voltaire's enlightened advocacy of civil liberty was the subject of censorship, in 1779 de Beaumarchais established his own printing house in an old fortress at Kehl, on the banks of the Rhine in south-west Germany. So delighted with the perfect match of subject and medium, he printed etchings of both Voltaire and Baskerville as frontispieces. (Correspondence between them more than two decades earlier had revealed Voltaire to be an

admirer of Baskerville's types and Baskerville to be an admirer of Voltaire's writing and free-thinking political beliefs.)

But his delight was premature: two contemporary accounts of the establishment of the foundry and presses at Kehl revealed only chaos and bewilderment. There had been a great underestimation of the levels of skill required to print to Baskerville's standards. Many of the original punches were damaged and had to be replaced, and much of the original and newly made type failed to print accurately or smoothly. So much of Baskerville's success, de Beaumarchais and his appointed craftsmen discovered, was dependent on the correct ink, paper and preparation of the printing beds. Even the enlisting of some of Baskerville's men – including, it is thought, his Birmingham punchcutter John Handy to repair broken type – failed to yield satisfactory results. At its peak in the 1780s, the Kehl printworks employed more than 150 men travelling from France, Switzerland and all quarters of Germany to produce Voltaire's works on forty presses, but the supply of labour was so scarce that at one time key roles were assigned to two fifteen-year-olds. Anyone was welcome 'provided that the wage he demanded was little, and the thinking he did was even less'. The 'thinking' was to be the sole job of the

tyrannical works director Jean-François Le Tellier; efficiency and quality would only improve after de Beaumarchais made his first visit to the factory in 1784, resulting in Le Tellier's departure.*

Sales of Voltaire were disappointing, not least because another publisher brought out a competing cheaper edition. De Beaumarchais was determined to use his Baskerville in other ways, this time at a foundry established near his new house by the Bastille. But again there were problems. Transporting the original punches from Kehl was beset with delays, and in 1790 de Beaumarchais wrote to the mayor of Paris to help liberate his chests, 'which contain typographic riches of so precious a kind and of such unique beauty that I am most apprehensive ...

> For steel punches are not books, nor even
> characters to print books, but are only what are
> used to find and cast the most beautiful printing
> types known, a kind of property which is nobody's
> concern, the destruction of which would not only

* This account of Kehl derives principally from a five-day visit to the foundry by Étienne Anisson-Duperron, the last director of the Louvre's Imprimerie Royale. The larger story of Baskerville's type in France and Germany comes from *The Survival of Baskerville's Punches* by John Dreyfus, privately printed in 1949 as a Christmas present 'for friends in printing and publishing'.

be an enormous loss to me, but an irreparable
harm to the splendid art of printing.

The letter – or time – worked. The Beaumarchais
Baskerville was used widely, most prominently for
the *Gazette National, ou le Monitor Universal*, the Parisian
newspaper that most thoroughly documented the
traumatic dislocations of the period.*

De Beaumarchais survived the Revolution, but
his foundry was closed in 1794 along with all the
properties in his estate. After his death in 1799, the
Baskerville punches passed to his daughter Eugénie,
and after her death in 1818 to Pierre Didot and
his son Jules, who had established a large foundry
eight years before, and wrote to a client that he had
bought his new material 'by chance and simply as a
matter of curiosity'. And then Baskerville went on
a journey of disfavour and obsolescence, a century
of loss.

Didot's foundry sold its Baskerville punches and
matrices to the printers E. Plon, Nourrit et Cie,
where they were used without much effect until 1898,
when they were sold as part of a job lot – cheaply,
unrecognised and, according to one report, in rusty

* The mayor who may have helped de Beaumarchais retrieve his
Baskerville was Jean Sylvain Bailly, an influential astronomer before he
turned to politics; he was guillotined three years later.

*Type for sale: many sizes available near the Bastille in the
nineteenth century.*

disrepair – to Fonderie Bertrand. About twenty years later they were purchased (along with other Didot faces) by the much larger foundry Peignot et Cie (later Deberny et Peignot), after which fortune smiled on Baskerville once again.

The American book and type designer Bruce Rogers recognised what he thought might be the original Baskerville in an old E. Plon specimen book, a hunch confirmed when, employed as typographical adviser to the University of Cambridge during the First World War, he found a Baskerville specimen sheet in a local bookshop and was able to compare the two. Back in the United States after the war, and now advising the Harvard University Press, Rogers secured a fount of Baskerville type from France and began setting up the press for seven books; under his direction the books looked both traditional and modern, and adhered perfectly to his dictum that 'the first requisite of all book design is orderliness'.*

And from here the good word spread. Rogers was also typographic adviser to the Monotype Corporation in Salfords, Surrey, and in 1923 a modernised Baskerville was considered to be a perfect

* Rogers's most enduring typeface is Centaur, a modern roman face inspired by the fifteenth-century Venetian designs of Nicolas Jenson.

selection for its hot-metal casting machines. (Its rival, Linotype, cut its own Baskerville in the same year.)

In the early 1950s, with Baskerville's reputation newly secured, Charles Peignot began considering returning the punches and matrices to England. The metal letters had spent almost 180 years in France and Germany; their new destination was Cambridge, where Baskerville had printed his Bible to widespread acclaim but financial compromise (to the slight consternation of civic officials and type scholars in Birmingham, one may assume). A reporter from *The Times* attended the handover ceremony at Emmanuel College in March 1953, judging it 'as appropriate as it is generous', and he was joined at the event by Stanley Morison, who had helped create Times New Roman in 1931, and at Monotype had done much to promote Baskerville's current popularity among printers.

The punches still reside in Cambridge, at the Historical Printing Room at the University Library. And they are now the subject of new analysis by the world's leading Baskerville expert.

Caroline Archer-Parré is chair of the Baskerville Society, and was seemingly born to the role. Her

father was a type compositor in Birmingham and then a printing lecturer, and her childhood home contained four small printing presses and racks of type. Baskerville became an academic specialism for her in 2010 at Birmingham City University, where she is professor of typography and co-director of the Centre for Printing History and Culture.*

Since the pandemic, Archer-Parré has lived in Cornwall, from where she travels to Birmingham to teach. When we spoke via Zoom, the shelves behind her in her study in Truro were crammed with Baskerville volumes, fine copies and broken ones, and at my prompting she says she feels a little bit of 'transmission' with the printer when she opens his books. Her favourite is a very small edition of the *Book of Common Prayer*, the version with double columns and no borders: 'Exquisitely perfect – so clean and so precise and modern.' And during lockdown in 2020 she led a successful crowdfunded campaign to keep a unique Baskerville Bible – the copy once belonging to the family of Birmingham industrialist

* With Malcolm Dick she is co-editor of *John Baskerville: Art and Industry of the Enlightenment* (Liverpool University Press, 2017), a major specialist study, among other things, of Baskerville's Greek types, social networks and bindings.

Matthew Boulton – from going abroad at auction.*

Her interest in Baskerville doesn't end with
the books. 'We have a little portrait of Baskerville
in our bedroom. Apart from my husband, he's the
first person I see every morning. I get even more of
a thrill seeing and touching his punches, the direct
physical contact.' She was waiting to hear whether a
newly proposed research project into these punches
at Cambridge had been awarded a significant grant.
The new work would be a collaboration with spe-
cialists in metallurgy, microspectroscopy and the his-
tory of printing, collectively aiming to discover how
many of the punches are Baskerville/John Handy
originals and how many are French additions from
later years, and to learn more about eighteenth-cen-
tury punchcutting in general. Not long after exam-
ining the punches in Cambridge in the 1950s, the
printing historian John Dreyfus estimated that about
two-thirds were original. 'But he was relying on
gut-feeling,' Archer-Parré told me, and the new re-
search will apply more scientific methods. Even the
preliminary work has revealed 'hitherto unnoticed
scratches, dents and surface undulations', tool marks

* She raised £57,000 in benefactor pledges in a month, enough to
persuade the vendors, the Birmingham Assay Office, to withdraw it
from sale. It now resides at Birmingham University's Cadbury Research
Library.

unique to the maker, discoveries that have suggested to the researchers that up to four punchcutters may have been responsible for the Baskerville type that now resides in Cambridge.

10. INDUSTRY AND GENIUS

I t's a lovely and unusual thing, and fairly indestructible, one would have thought. Six hefty carved pillars in Portland stone, each five feet high and three feet wide, with one reversed bronze letter on the top of each, spelling out VIRGIL in Baskerville. They are bookended by two bigger but lower blocks, one inscribed 'John Baskerville – Letter Founder', the other 'Industry and Genius – A Fable'. These giant punches sit staunchly outside Baskerville House in Centenary Square, in the heart of the Jewellery Quarter, right next to the reflecting pool with water jets, directly over the foundations of Easy Hill where Baskerville once lived and worked, and where he was originally buried. (Baskerville House once housed Birmingham City Council's planning department, but now the building contains commercial offices

and a health club.)*

'Industry and Genius' is the work of the painter David Patten and the sculptor Mitchell House. In the late 1980s, in conversation with the Public Art Commission Agency, Patten hoped that Baskerville wouldn't be ignored in the city's millennial plans to develop for the future and celebrate its history. He thought his lower-case g, 'the most exquisite thing ever to have been made in Birmingham', and was determined to include it in his work. Patten drew up a three-word shortlist: Birmingham (considered too long and thus too expensive), Ergo (his favourite, but barely resonant of Baskerville's work and too obscure), and Virgil, his first major publication.

Patten collaborated with House to create the punches, a nice parallel with Baskerville enlisting John Handy for the same task, and they found stone-masons in Lincolnshire to cut the punches. Patten

* David Patten named his work 'Industry and Genius' after an anonymous poem which appeared in the local *Aris's Birmingham Gazette* in 1751, just after Baskerville began working on his type foundry but years before he published his Virgil. The poem, in the Spenserian style, references his name in the opening line, while the rest alludes to his japanning success and the growth of local industry. An excerpt:

O B--! in whom, tho' rare, unite, / The Spirit of Industrie and eke the Ray /Of bright inventive Genius; while I write, / Do Thou with Candour listen to the Lay / Which to fair Birmingham the Muse shall pay,/ Marking beneath a Fable's thin Disguise, / The Virtues its Inhabitants display; / Those Virtues, when their Fame, Their Riches rise, / Their nice mechanic Arts, their various Merchandise.

A constant Virgil: the Baskerville memorial punches in Centenary Square.

had one consideration: the work should not be re-
garded as art; he wanted buskers to perform on the
end blocks and passers-by to sit for a moment on the
letters. This was an irregular and archaic thing, after
all: a word and a world carved backwards, some-
thing both familiar and thought-provoking, like a
gravestone.

I visited the giant punches on a clear afternoon
at the end of January 2023, and I was struck by how
worn they looked, how weather-beaten, as if they
had already printed many huge things and would
soon need replacing. The v had a veiny crack down

one side, and the g had the sort of green patina one sees on bronze sculptures centuries older. It was probably the only public memorial to a typeface and a type founder in the world. I think J.B. would have liked its power, its incongruity, its nonconformity.

A few yards away, the Library of Birmingham contains the only inscription we can be sure was crafted by Baskerville himself, the slate advertisement for his gravestone carving.

Grave Stones
Cut in any of the Hands
By
John Baskervill
WRITING-MASTER

It dates from the late-1720s or early 1730s. Each line shows his talent for a different script: an old German-style black-letter Fraktur for the first, a lower-case Caslon-style roman for the second, an elaborately swirled indulgent flourish for 'By', an Old English gothic for his name and a sloped italic all-caps roman for his trade.

Baskervill offers his services as a stonecutter at the start of his career.

I went looking for it on the top floor, where Caroline Archer-Parré had last seen it. It was on the ninth floor behind a pillar, apparently, in a glass case with silver framing mounts at the corners. It was near the library's special Shakespeare Memorial Room, next to a navy-blue plaque awarded by the Birmingham Civic Society to commemorate Marie Bethell Beauclerc (1845–97), 'First female reporter in England, Pioneer of shorthand and typewriting'. But the Baskerville slate wasn't there. I asked a staff member where it might be, but she had no idea. She used her walkie-talkie to call a couple of colleagues, but drew a blank. Finally Rachel Clare, a senior

assistant in the archives department, located it: 'I
can confirm that it is safely held in our stores.' Until,
at some uncertain point in the future, Baskerville
will be on the move again.

Another visit to Bauman Rare Books on Madison
Avenue, this time in person. Some of the treasures
I'd seen online months before were still for sale, their
desirability further enhanced by their setting. For
here was a wood-panelled lair to rival the fine rooms
of the Morgan Library nearby, the leathery tang of
antiquity and refinement, a collection unlike any
other. And unlike the Morgan, which holds three
Gutenberg Bibles and enough Baskervilles to fill a
trunk, everything here is for sale.*

I was welcomed by Erin Mae Black, a special-
ist in the Renaissance with an enthusiasm for rarer
volumes of scientific and women's history. In her

* David Bauman, who founded the business with his wife Natalie in 1973,
says: 'One of the most gratifying things to me is still when somebody
comes into one of our galleries and says, "I never imagined anything
like this could exist."' One of most illuminating books on sale when I
visited was something modern – David Foster Wallace's *Intimate Jest*. A
first edition from 1996, it had an intriguing inscription, a springboard for a
novel: 'For Ralph – In friendship, so long as you KEEP YOUR HANDS
OFF MY SPOUSE.' It was accompanied by a sketch of a frowning face.

biography she quotes Ursula K. Le Guin: 'We read books to find out who we are.'

What may we discover about ourselves from the latest riches on display, including first editions of *Jane Eyre, Emma, The Wonderful Wizard of Oz* and the Brandenburg Concertos? And what from its greatest Baskerville acquisition, the Cambridge Bible?

This particular copy, a large, thick folio ($13\frac{1}{2}$ × 20 inches), is bound in black morocco with intricate gilt decoration and marbled endpapers. Its catalogue entry emphasises its splendour. This edition 'has always been regarded as Baskerville's *magnum opus* and is his most magnificent as well as his most characteristic specimen,' said William Herbert; 'His most ambitious undertaking … widely acclaimed as his masterpiece,' echoed Joseph Blumenthal's *Art of the Printed Book*.

Bauman was offering it at $18,000. Beyond my budget, alas, but I asked to see it, another chance to appreciate the great man's greatest challenge. And I could compare it to the copy I'd seen in Birmingham.

'Ah,' said Erin Mae Black. 'I think you're out of luck. It's not here. I think it's at another of our galleries.' She checked her computer. Since 1982 Bauman has also had a branch in Philadelphia. But it's not there either.

'Here it is – in Las Vegas.'

Bauman opened a gallery in Las Vegas in 2008, one of the Grand Canal Shoppes separating the Venetian and Palazzo hotels. 'A client may have requested to see it there, so we flew it over.'

Of course. Birmingham, Cambridge, fake Venice in Vegas, wherever: Baskerville always liked a bit of show. In Vegas his Bible joined a roster of slightly less rarefied first editions than those on Madison Avenue: *The Grapes of Wrath*, *The Old Man and the Sea* and *Snoopy and the Red Baron*. And its pages offered all the most cautionary tales: 'You cannot serve both God and Mammon' (Matthew 6:24); 'Keep your life free from love of money, and be content with what you have' (Hebrews 13:5); 'For what will it profit a man if he gains the whole world and forfeits his soul?' (Matthew 16:26).

What have these proverbs in common? Little beyond a beautiful way with words.

The Baskerville Bible I had consulted in Birmingham was once owned by his wife Sarah. We have already seen how visitors to Baskerville's japanning works and type foundry regarded her as authoritative and influential, and evidently a crucial figure in her husband's success. Like her husband, she was also

headstrong and resilient. She had endured gossip and scorn when their relationship, which began in her role as his housekeeper after her first husband deserted her and their three children, had developed into something with a strong emotional attachment long before her first husband died (in 1764 – John and Sarah married shortly afterwards).

Her name from her first marriage was Sarah Eaves, and she has been immortalised as such in type. Mrs Eaves, a display face created by Zuzana Licko in 1996, is a strong serif in the neoclassical style; it is an updated, looser, wider-proportioned version of Baskerville, based on how Baskerville looks in his early printed books rather than the flatter photo-compositional or modern computer versions, many of which tried to make perfect copies of his punches (indeed, Licko's inspiration sprung from studying original Baskerville editions, with all their quirks, anomalies and ligatures, at the Bancroft Library in Berkeley, California). On its release, its creator wrote of how she hoped to maintain Baskerville's openness and lightness, while also limiting the more extreme variations of his letters' thick and thin strokes. And Mrs Eaves was a huge success, not least on book jackets (where it rivalled Albertus and Futura), but also in many other situations where more formal displays of traditional type are called for (wine

bottle labels, greetings cards, corporate signage). Licko then gave Mrs Eaves an equally airy sans serif type husband, Mr Eaves, and then gave them both relatives Mrs Eaves XL Serif and Narrow, Mr Eaves Sans and Modern, and Mr Eaves XL Modern and Narrow. All flourished.

In many ways, Mrs Eaves was an unlikely choice for Licko, a Czech-born typographer who established her reputation with the influential visual design magazine *Emigre* that she created in California with her husband Rudy VanderLans. *Emigre* celebrated the wilder shores of typography made possible by the new-found freedoms of computer bitmap design. *Emigre* typefaces included Senator, Narly, Journal, Variex, Program and Mason, each of which looked very much like they sounded – stiff and formal, twisted and challenging, handmade and scrappy, random and erratic, digital and unrelenting, medieval and crafted.

In 2009, just as she was working on the sans version of Mrs Eaves, I had an email conversation with Licko about her work, and she wrote how amazed and proud she was to see Mrs Eaves and Filosofia, her update on late-eighteenth-century Bodoni, feature so often on book jackets. She then offered an illuminating insight into her designs by comparing her type work with her other creative endeavour,

ceramics. In my mind it set up a loose parallel with John Baskerville's dual pursuits of type founding and japanning.

'Ceramics began for me as a distraction to the tedious aspects of typeface design work. Over the years, I've discovered that pottery and type design are connected in many ways, some of which are contrasting. Of course, both disciplines deal with creating visually and structurally balanced shapes. Both deal with the duality of inside & outside form. And both require resolving transitions of curves.

'The differences between these two disciplines, however, are equally intriguing. The making of a ceramic piece is finite, relatively instantaneous, and exists in the physical realm, while a typeface design has no physical boundaries and can be reworked

A tribute to Sarah Baskerville: Mrs Eaves by Zuzana Licko.

endlessly. In fact, a typeface design requires a meticulous reworking of elements over a long period of time. Often I must put a typeface away for weeks, even months, in order to resolve problems that seem unsolvable at the time. A piece of ceramics ultimately exists as a static entity, whereas each letter in a typeface is designed to work in conjunction with the other letters, in virtually any combination, and so, the appearance of the typeface in use will differ, depending on the particular letter combinations and typographic setting.'

I told Licko that I had recently talked to the typeface designer Matthew Carter, who, among many other popular typefaces, made Big Moore, based on a version of Fry's Baskerville. He said that when it came to the actual design process, 'you have to find the fascination greater than the frustration'.

'Yes, I agree that both fascination and frustration are involved,' Licko agreed. 'At the beginning, as a typeface is conceptualized, every detail gets questioned. This process is fascinating because it makes you realize how each detail affects the resulting work, as many details are repeated among characters, which multiplies the effect. Eventually this can turn to frustration because it seems the process will never end. In fact, a typeface is never finished because there is always the need for additional language

support, additional weights, additional ligatures, or additional formats.'

Luc Devroye, of the School of Computer Science at McGill University, Montreal, has compiled an exhaustive list of Baskerville interpretations, almost all made in the last forty years. They include Berthold Baskerville (1992, Günter Gerhard Lange), sold by Adobe; Fry's Baskerville BT, a bitstream version of Baskerville Old Face; and Baskerville 1757, published by Timberwolf Type and based on Baskerville's edition of Virgil. Devroye particularly favours the font called Baskerville Caps. The first, often called Baskerville Old Face, was cut in 1768 by Oscar Moore for the Fry type foundry, an offshoot of the Fry's Bristol Quaker chocolate dynasty. The fact that the Fry foundry later concentrated on Caslon reflects Baskerville's relative unpopularity at the time. Should you be looking to buy a digital version of Baskerville that most closely resembles the original, you can download Baskerville Original Pro by František Štorm from MyFonts.

But isn't everything a variation or a revision? Gutenberg's work was based on medieval manuscripts, handwriting rethought as type. Baskerville

drew inspiration from the cursive flow he taught in schools and William Caslon, so that his punchcutter John Handy took months to carve refinements to the serifs on a simple A and H. The lineage is as long as the world's circumference, while each new indentation has its own place on the timeline.

In February 2023 I was welcomed at Cambridge University Library by Colin Clarkson, the recently retired head of Modern Research Collections and curator of the Historical Printing Room. He still holds eight-week courses in the printing room, during which students learn the lore of letterpress surrounded by a beguiling repository of old presses and inky kit, and trays of type labelled Hebrew Upper, Diamond Italic and Baskerville Corps 10 (10-point body text). There is a large nineteenth-century gilt-framed set of printers' instructions – 'Every Pressman [must] wash his hands before he takes Paper out of the Warehouse … under the penalty of Twopence' – and beneath this lies a more familiar refrain:

THIS IS A
PRINTING OFFICE

CROSSROADS OF CIVILIZATION

Clarkson escorts me to visit Liam Sims, a rare books specialist at Cambridge University Library, where Baskerville's original punches have been cared for since 1953. Here are the silent witnesses, almost 2,599 individually carved letters in many sizes, the direct physical link to 1750s Birmingham.

Sims has already laid out the seven wooden padded dispatch cases containing the wares. The boxes, probably made in France in the late-nineteenth or early twentieth century, are lined with a brown felt, and divided into several thin wooden strips, a line of type within each, their size still demarcated in French: Romain c.14, Romain c.16, all the way to the chunkiest Romain c.72; there are also italic fonts, and a choice of both lower and upper case. The slugs of metal, each a few centimetres high, have been cleaned and polished to a dull silver. They are all approximately the same height, while widths vary arriving to the size of the letter carved in reverse at their tip. A typed note placed in one of the boxes explains, 'These steel punches would be driven into soft copper and from this the type would be made.'

This is not the complete set, and they are not all John Baskerville's originals; it is likely that hundreds of damaged letters were re-cut in France. I pull out the magnificent Q's in many sizes, and run

them along the tips of my fingers. My iPhone can record better close-ups than my eyes can transmit to my brain. I'm just happy to be among them, and I recall a conversation with Archer-Parré about Baskerville's reputation. When she met someone at a dinner party and they asked what she did, she found that Baskerville's life and work raised barely a flicker. Perhaps they thought of hounds. 'If they do know something about him it's most likely that they've seen his name in their drop-down menu. They might assume that it was something Microsoft knocked up.'

I look for the g's, another easily identifiable 'spot' letter, notable for its contrasting strokes and

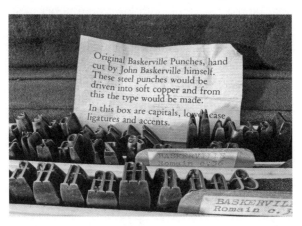

The original punches in Cambridge, an emotional encounter with the past.

The magnificent Q, the squirrelly tail still out on its own.

multidirectional curves, and its unclosed lower bowl.
But the g's are not here, for they have recently been
removed for microspectroscopy. Liam Sims then
locates them in a number of small white envelopes
elsewhere in the library, and after examination and
photography we reunite them with the rest of their
sorts. It is not hard to get emotional about type, al-
though it may appear feeble to express this openly.
But to touch these beginnings and weigh their past
is indeed a privilege, and I found it a highly moving
experience. What writer – what reader – would not
feel the same?

BIBLIOGRAPHY, REFERENCES
AND FURTHER READING

I would like to thank everyone who helped me with this book, especially Caroline Archer-Parré for her expertise and encouragement.

What follows is a brief list of books, journal articles and online references that have been valuable in writing this book. Some concern themselves specifically with John Baskerville and the Baskerville typeface, while others will be useful in placing his work within a wider context. The online links were intact at the time of publication. A few are behind firewalls and accessible only through subscription or an academic institution.

Archer-Parré, Caroline and Dick, Malcolm (eds), *John Baskerville: Art and Industry of the Enlightenment* (Liverpool University Press, 2017)

Ball, Johnson, *Caslon: Master of Letters* (Warwick: Roundwood Press, 1973)

Bennett, William, *John Baskerville: The Birmingham Printer*, 2 vols (Birmingham: School of Printing, 1937)

Benton, Josiah H., *John Baskerville: Type-Founder and Printer 1706–75* (Boston, 1914). Available online as a PDF: https://ia800206.us.archive.org/33/items/cu31924029503020 cu31924029503020.pdf

Bringhurst, Robert, *The Elements of Typographic Style* (Seattle: Hartley & Marks, 2016)

Dreyfus, John, *The Survival of Baskerville's Punches* (Cambridge: privately printed, 1949)

Frazier, J.L., *Type Lore: Popular Fonts of Today, Their Origin and Use* (Chicago: privately printed, 1925)

Gaskell, Philip, *John Baskerville: a Bibliography* (Cambridge: Cambridge University Press, 1959)

Hull, Robin, *John Baskerville: Shaping the Alphabet* (London: Robin Hull, 2015)

Knight, Stan, *Historical Types: From Gutenberg to Ashendene* (Delaware: Oak Knoll Press, 2012)

Lawson, Alexander, *Anatomy of a Typeface* (London: Hamish Hamilton, 1990)

McLean, Ruari (ed.), *Typographers on Type* (London: Lund Humphries, 1995)

Pardoe, Frank E., *John Baskerville of Birmingham, Letter-Founder and Printer* (London: Frederick Muller Limited, 1975)

Reed, Talbot Baines, *A History of the Old English Letter Founders* (London: Dawsons of Pall Mall, 1974)

Straus, Ralph and Dent, Robert, *John Baskerville: A Memoir* (London: Chatto & Windus, 1907)

Updike, Daniel Berkeley, *Printing Types: Their History, Forms, and Use, Vol. II* (Cambridge: Harvard University Press, 1927)

Walker, Benjamin, *The Resting Places of John Baskerville* (Birmingham: School of Printing, 1944)

Webb, William, *Three Great Printers* (Bournemouth and Poole College of Art, 1970)

PREFACE: THE ABC OF FONTS

Incunabula Short Title Catalogue at the British Library: **data.cerl.org/istc**

Andrew Solomon's op-ed: **nytimes. com/2004/07/10/opinion/the-closingof-the-american-book.html**

1. THE RIOTS

For more on the Birmingham Riots see: **theironroom.wordpress.com/2023/01/16/joseph-priestley-and-the-birmingham-riots**

An engaging overview of key contribution of the West Midlands to the Industrial Revolution is here: **revolutionaryplayers.org.uk**

2. JAPANNING

The Francis Meynell lecture: ***Journal of the Royal Society of Arts***, **vol. 100, 1952, pp. 573–91, jstor. org/stable/413681511**

For more on the craft of British japanning 1620–1820, see: **vam.ac.uk/content/journals/conservation-journal/issue-52 /the-development-of-english-blackjapanning-1620-1820**

3. MISPRINTS

At the time of writing, the Virgil was still on sale at Bauman's. If it's sold, new Baskerville arrivals are not uncommon: **baumanrarebooks.com**

A good selection can also be found at: **peterharrington.co.uk**

For more details on one particular edition see: **A.T. Hazen, 'Baskerville's Virgil',** *Yale University Library Gazette*, **vol. 11, no. 4, 1937, jstor.org/stable/40856971**

For more on Baskerville's choice of paper see: **A.T. Hazen, 'Baskerville and James Whatman',** *Studies in Bibliography*, **vol. 5, 1952, jstor.org/stable/40345203**

Cathleen A. Baker's analysis of Baskerville's Virgil is on SoundCloud: **soundcloud.com/ rarebookschool/baker-baskerville**

4. THE ART OF CUTTING

For the full correspondence between Baskerville and Robert Dodsley see: **John Bidwell, 'Designs by Mr. J. Baskerville for Six Poems by Mr. T. Gray', Book Collector, Autumn 2002.**

A facsimile of Fred Anthoensen's account of punchcutting from 1939 is here: **circuitousroot.com/**

artifice/letters/press/typemaking/literature/
general/moxon-1750-anthoensen-1939-art-of-
cutting-0600rgbjpg.pdf/

A step-by-step film of the punchcutting process, narrated by Matthew Carter: **typography.guru/ video/gravers-files—the-lost-art-oftype- punch-cutting-r76**

5. TRUST EXERCISE

The results of the experiment are, at time of writing, still available at: **archive.nytimes.com/ opinionator.blogs.nytimes.com/2012/08/08/ hear-all-ye-people-hearken-o-earth**

A good sampling of the Pentagram book, with illustrations, is here: **pentagram. com/work/pentagram-papers-44- hear-all-ye-people-hearken-o-earth/ story**

6. Q & A

For the full account of Beatrice Warde's appreciation of Baskerville see: **'The Baskerville types: a critique'**, *Monotype Recorder*, vol. 26, no. 221, 1927.

Nicolas Barker provides a richly illustrated survey of Beatrice Warde's life: **youtube.com/ watch?v=TfHZJGJbWiA**

A transcript of an illuminating interview from 1959 with Beatrice Warde may be found here: **eyemagazine.com/feature/article/ beatrice-warde-manners-and-type**

Craig Eliason's discussion can be found at *Design Issues*, **vol. 31, no. 5, Autumn 2015, MIT Press.**

Mark J. Bishop's analysis of Baskerville: **uxdesign.cc/baskerville-typeface-specimen- a-ui-case-study-1eeff7663bd77**

For more on Benjamin Franklin's own print work, and his love of hoaxes, see Carla Mumford's essay: **'Benjamin Franklin's Savage Eloquence: Hoaxes from the Press at Passy, 1782', *Proceedings of the American Philosophical Society*, vol. 152, no. 4, 2008, jstor.org/stable/40541605**

7. THE ART OF ANGLING

A comparative study of Bibles, placing Baskerville's edition in context: **collections. museumofthebible.org/artifacts, The Baskerville Bible**

Baskerville's Bible (specifically the one belonging to Matthew Boulton's family) is shown to great effect in this short film. The Centre for Printing History and Culture has many other valuable Baskerville features, as well as those relating to the history of printing in general. **cphc.org.uk/ appeal-to-save-birminghams-iconic-bible**

8. A MOVEABLE TYPE

Caroline Archer-Parré's account of Baskerville's post-mortem life is available as a pdf: **tandfonline.com/doi/pdf/10.1080/0047729X. 2022.21262388**

A brief illustrated account of Baskerville's burials: **theironroom.wordpress.com/2016/10/ 31/the-burials-of-john-baskerville/**

9. COMING HOME

Details of Cadbury Research Library's holding of Baskerville volumes, and how to visit them, may be found here: **birmingham.ac.uk/facilities/ cadbury**

John Dreyfus's early history of the Baskerville punches may be found in *The Library*, volume s5-V, issue 1, June 1950. doi.org/10.1093/library/s5-V.1.26

A more recent and comprehensive account, 'The Baskerville Punches: Revelations of Craftsmanship' by Caroline Archer-Parré, Ann-Marie Carey & Keith Adcock is here: **doi.org/10.1 080/0047729X.2020.1767973**

10. INDUSTRY AND GENIUS

For a comparison of more than eighty Baskerville designs see: **luc.devroyc.org/showcase-baskerville-/**. Luc offers a vast and highly recommended searchable encyclopaedia of all things type and typography at **luc.devroye.org/fonts.html**

Papers and minutes at the University of Cambridge regarding the inventory of Baskerville's punches: **archivesearch.lib.cam.ac.uk/repositories/2/archival_objects/575021**

For more on Mrs Eaves, Mr Eaves and Zuzana Licko see: **emigre.com/Designer/ZuzanaLicko**

IMAGE CREDITS

INDEX